IMAGES
of America

ALTAPASS

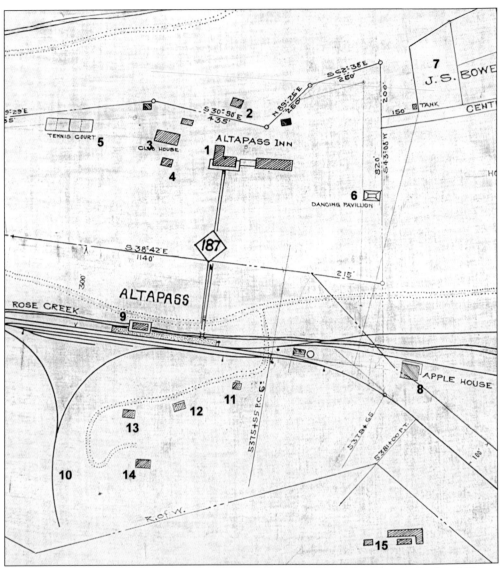

MAP OF ALTAPASS, 1924. A railroad map shows the areas around the Altapass Railroad Depot and the Altapass Inn in 1924. Numbers indicate the locations of major landmarks. Near the Altapass Inn (1) are the barns and servants' living quarters (2), the Inn Clubhouse (3), rental cottages (4), tennis courts (5), and the Dance Pavilion (6). Nearby are the property of J.S. Bowen (7), the apple house (8), the Altapass Train Depot (9), the railroad turning wye (10), the section foreman's house (11), a railroad rental house (12), the stationmaster's house (13), the Railroad Boarding House (14), and the Holman Hospital and Library (15).

ON THE COVER: Plato Hall worked at the Altapass orchard for 55 years. His family has lived in the Halltown area of Altapass for four generations. This photo was taken by C.E. Westveer of Little Switzerland in the mid-1970s.

IMAGES
of America

ALTAPASS

Judy Carson and Terry McKinney

ARCADIA

Published by Arcadia Publishing
Charleston SC, Chicago IL, Portsmouth NH, San Francisco CA

Printed in Great Britain

Library of Congress Catalog Card Number: 2004117375

For all general information contact Arcadia Publishing at:
Telephone 843-853-2070
Fax 843-853-0044
E-mail sales@arcadiapublishing.com
For customer service and orders:
Toll-Free 1-888-313-2665

Visit us on the internet at http://www.arcadiapublishing.com

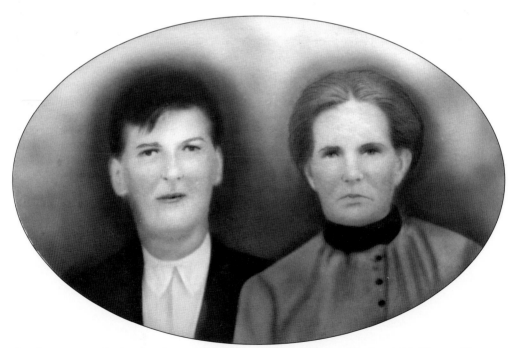

AN ANCESTRAL COUPLE OF ALTAPASS—WILBURN AND SARAH GALETHA MCKINNEY BIDDIX.
Wilburn was the son of George and Nancy Smith Biddix. His great-grandfather, John Biddix Sr., served in the American Revolutionary War. Sarah Galetha was the daughter of Jason McKinney and Nancy Biddix and a granddaughter of Charlie McKinney, the first settler at McKinney Gap.

CONTENTS

ACKNOWLEDGMENTS

This book is the result of a whole community of people who, over nine years' time, shared photos from family albums and stories from around their dinner tables. They encouraged us to preserve their history by compiling our collections in this book. We especially wish to thank our spouses, Bill Carson and Ruth McKinney, who patiently tolerated our obsession with this project and the many, many hours we spent assembling the materials. Major contributors of photos and stories were Calvin and Margaret Hall, Guss McKinney, Joe "Bud" Biddix, Cora Dawn Biddix Markford, Dick and Cornelia Vance, Bill Carson, Nettie McKinney, Sadie McKinney, Jack McKinney, Frances Geneva Biddix Mace, Joan and Gary Forbes, Vivian Harris, Fred Medford, Jack Medford, Vince Hefner, Jim Hite and Hite Effects Studio, Lloyd Glenn, Davis Godwin, Georgia Henline, Olin Hefner, Mildred Hefner, Gwen Hawley, George Morgan, Roy "Buddy" Wiseman, Doug Long, Faith Hefner, Carter Biddix, Wayne McKinney, Gladys and Ray Saxon, Russell Saxon, Decima McKinney, Elvira and Jennings Bryant, E.J. Biddix, Ruth Lowery, and Wyonne Harrison. Copyreaders were Kit Trubey and Margaret von Rosen. We also wish to thank the authors of the following books that served as research tools for *Altapass*: Estalena Harper's *Charles McKinney and Related Families*; Lloyd Bailey's *The Heritage of the Toe River Valley*; Louisa Duls's *The Story of Little Switzerland*; N. Brian Westveer's *The Clinchfield Loops*; Bill Carson's *Stories of Altapass*; Harley Jolley's *The Blue Ridge Parkway*; Muriel Sheppard's *Cabins in the Laurel*; and Alberta Pierson Hannum's *Look Back With Love*.

INTRODUCTION

When pronounced properly, Altapass rolls off the tongue like a sweet melody. Say the first syllable like the name "Al" and say it out loud. Given by the Carolina, Clinchfield, and Ohio (CC&O) Railroad a century ago, the name designates an important railroad transition: the crossing of the Eastern Continental Divide. From Altapass it is downhill in both directions along the track—hence the connection of alta, meaning high, with pass. Yet Altapass itself is a low point in the Eastern Continental Divide, and it is uphill in both directions along the Blue Ridge. Mathematicians would call this a saddle point. Full of simultaneous ups and downs, this aptly describes Altapass's history as well.

The American Indians referred to the Blue Ridge as the Blue Wall, and it was quite a barrier to early settlers. They sought out the easiest way to cross the Blue Wall, and that was via the Yellow Mountain Trail through McKinney Gap at what was to become Altapass. Geography made this place one of the most historically active locations in the entire Blue Ridge. For more than a century before the railroad came, the settlers followed the Yellow Mountain Trail toward the western lands. Some built cabins and settled here—Davenport, Wiseman, McKinney, Biddix, Hefner, and Hall are names still found on mailboxes hereabouts.

The Revolutionary War was won in the South, and the turning point came when the Overmountain Men defeated Ferguson at King's Mountain. Those frontiersmen left the safety of the Blue Ridge by following the Yellow Mountain Trail backwards. This march is commemorated by the Overmountain Victory National Historic Trail, which runs through Altapass.

Among early settlers, Charlie McKinney stands out. He was the land-grant owner of the gap that bears his name and its first resident, owning 1,200 acres. Charlie, a farmer by trade, had four wives at the same time in four separate houses in the gap, all within hollering distance. This family produced 48 children, verified through census records, although family legend places him with up to seven wives. McKinney is the most frequent surname in Altapass and surrounding locations to this day.

The Yellow Mountain Trail changed Altapass from Native American hunting grounds to settler farms slowly, even with the extraordinary contributions from Charlie McKinney. The coming of the railroad at the turn of the 19th century had immediate impact on Altapass. The new source of transportation enabled logging, mining, large-scale agriculture, land development, and tourism. As time passed, it opened up manufacturing as well.

These sudden changes brought opportunity and challenge to Altapass. Old concepts of education, health, and family were not sufficient to cope with the changes. Lydia Holman, a

missionary from Boston, came to live her life in Altapass. She led the struggle to raise the health and education norms and change the role of women to meet the new environment of Altapass.

Altapass was the premier tourist stop on what was then the Clinchfield Railroad, with a golf course, two resort hotels, and a railroad boarding house. Altapass was a tourist community, even subdivided into lots to sell to tourists. Just when things were going well in Altapass, abrupt, catastrophic change occurred: the main highway bypassed McKinney Gap, and the railroad cancelled the passenger service. Two main bases of the economy, tourism and land development, vanished almost overnight.

As this book was being written, the remaining economic strengths of Altapass, manufacturing and commercial agriculture, have also faded. The community strengths are its people and the beauty of the location. Land development is finally beginning to take hold, 100 years after the railroad started people thinking that way. The constant at Altapass is change, and Altapass is a saddle point in many ways.

One
ROOTS THAT RUN DEEP

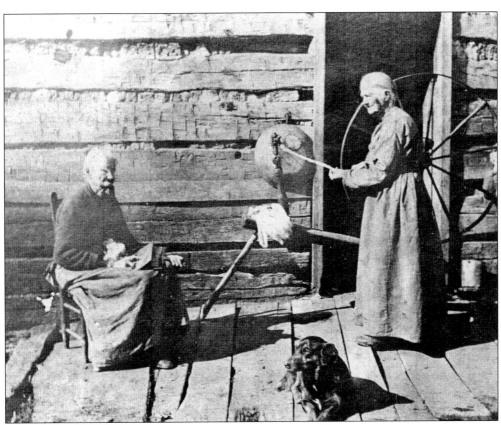

AUNT NANCE DIXON AND "FLURIE" HOLLIFIELD. These women were daughters of Charlie McKinney and Peggy Lowery. The women of 1900 made almost everything their families used.

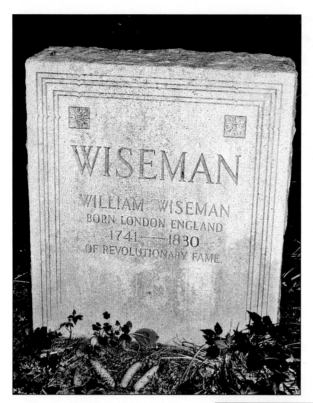

WILLIAM WISEMAN. Wiseman was one of the earliest settlers in the Toe River Valley. In 1780, Wiseman obtained 360 acres of land originally granted to Samuel Bright, a loyalist who lived three miles from McKinney Gap. Wiseman married Mary Davenport, and the William Wiseman ledger book recorded 12 children by Mary. He had seven more children with his second wife, Lydia Bedford. Other early settlers of the area included John Vance, Sam and William Bright, William Pendley, Dan Harris (a minister), and William Davis.

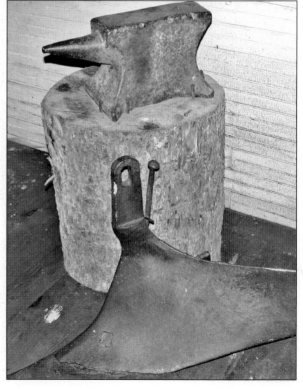

A TALENTED MAN. William Wiseman taught 14 to 16 hours a day, made exquisite furniture, and farmed. He built a dam on the Toe River and installed the first up-and-down sash sawmill pulled by waterpower. He invented a woodworking machine, tanned leather, and had a blacksmith shop, a gristmill, and a mill for grinding flour. This photo shows a plow made by William Wiseman in the late 1700s on the anvil shown next to it. The plow measures 38 inches from the tip to the moldboard.

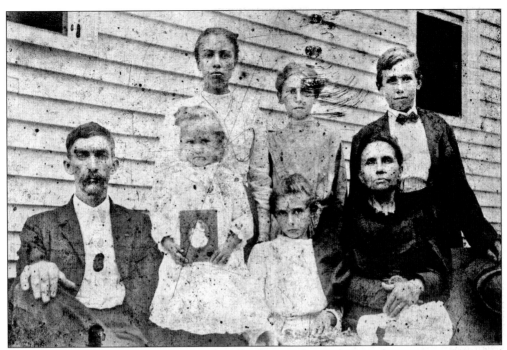

An Early Davenport Family. The family members in this photo are unidentified Davenports. The original photo was too faint to show any of the facial features, but computer technology managed to retrieve these faces from the past.

Brights, Davenports, and Grants. The Bright and the Davenport families lived in Culpepper, Virginia, and Samuel Bright's wife was said to be a Davenport. Bright established a plantation before the king of England decreed that all mountain land was Indian territory. The Davenports joined Samuel Bright shortly before the beginning of the Revolutionary War. Around 1790, the Davenports put down roots near Bright's farm. In the mid-1790s, the Grants passed through the region in the dead of winter. Harsh weather forced them to stay at Bright's place until spring. That winter, William Wiseman performed large numbers of marriages between the Bright and Grant families, and eventually the Grants and Brights moved west together. William Wiseman married Mary Davenport.

"COVE CHARLIE." Charlie McKinney came to the Blue Ridge Mountains around 1796 and settled in a scenic cove on the face of a mountain ridge in Burke County. In 1842, his farmland became a part of McDowell County. Historians say Charlie came from Virginia with a wagon full of apple seedlings, the first apple trees planted on the south side of the Blue Ridge. He came with his parents, William and Mary, and 11 children. Charlie received a land grant in 1796 for 100 acres and later accumulated 1,100 more acres.

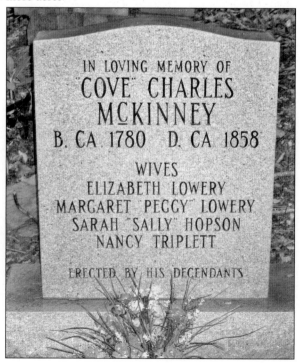

CHARLIE'S GRAVE. Charlie arrived in the mountains with one wife and possibly another. Eventually he had four wives and 48 children. Each wife had her own home on land Charlie willed to her. Uncle Jake Carpenter's obituary for Charlie said the four wives and families all got along together and there "warn't no har pullin'." Charlie "made brandy all his life, never had any foes and got along smooth with everybody." In August 2003, Charlie's family dedicated a handsome stone for his gravesite in a peaceful cemetery in the woods close to the Blue Ridge Tunnel.

12

MERRITT BERGIN MCKINNEY.
Merritt, born 1825, was the son of
Charlie McKinney and Sally
Hobson, a midwife. Local legend
says "Wanderin' Merritt's" wife
Susannah "Susie" Washburn asked
him to collect firewood while she
was preparing the noonday meal.
While Merritt was picking up the
wood, a farmer came down the road
with a flock of turkeys. Merritt went
to Virginia with the farmer to sell
the turkeys at market. With money
in their pockets, they went on to
New York and took a ship to
Europe. Two years later, Merritt
returned home, picked up some
firewood, and walked into the
house. Susannah said, "Why Merritt,
how far did you have to go to get
that firewood?"

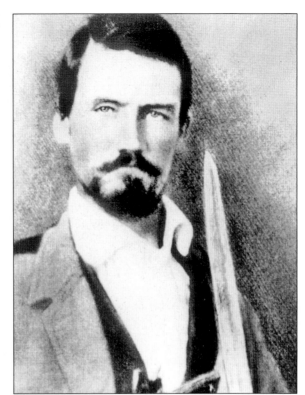

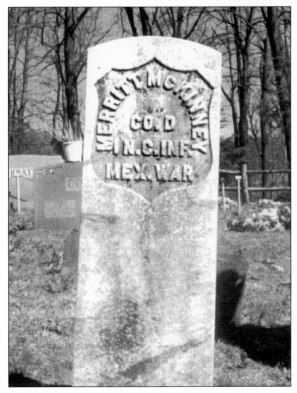

MERRITT'S GRAVE. Following
Susannah's death, Merritt married
Mary Hollifield in 1879. Merritt died
in December 1903 and was buried in
the Collis Graveyard in Little
Switzerland. His grave marker notes
his service in the Mexican War, but
he also fought in the War between
the States.

13

MERRITT SEVIER McKINNEY. Sevier was the son of Merritt Bergin McKinney and Susannah Washburn and the grandson of Charlie McKinney and Sally Hobson. His grandson was Plato Hall, and his great grandson is Calvin Hall.

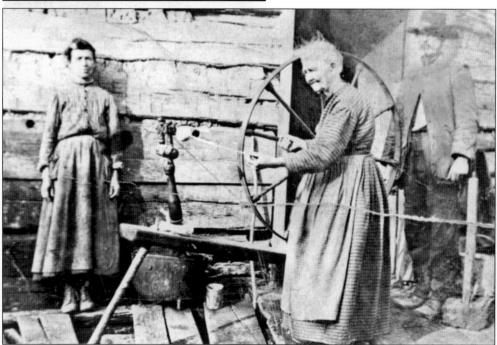

CHARLIE'S DAUGHTER. Flora "Flurie" McKinney Washburn Hollifield (center), born 1824, lived to be almost 100 years old. She carded and spun wool and made cloth on a handloom. Neighbor Janie Hollifield and Flurie's son Wade Hollifield watch her work. She was one of the last of the older generation to do this kind of work. The craft is now taught at nearby Penland School of the Arts. Flurie was the daughter of Charlie McKinney and Margaret "Peggy" Lowery.

WINFIELD SCOTT "BUD" McKINNEY.
Winfield Scott was the full brother of
Sevier McKinney. He was born in 1854
and died in 1923. His father, Merritt, was a
loyal soldier who fought in the Civil War
in spite of wife Susannah begging him to
stay home with his family. Winfield Scott,
named after one of Merritt's Confederate
officers, married Mary Dale.

BUD McKINNEY. Winfield Scott ("Bud")
is pictured here with his wife, Mary, and
his mother-in-law (name unknown).
Their ten children are Avery, Mag, Mary,
John, Stella, Clarence, Etta, George, Jim,
and Paul.

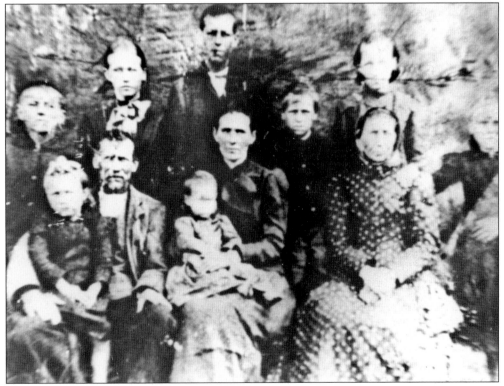

A Confusing Situation. Sam Quinn, on the left, is shown with Sevier McKinney in his later years. Sevier was Merritt McKinney's son. Merritt's second wife was Mary Hollifield. Her sister, Dove, married Sevier, making Merritt a father and brother-in-law to Sevier. Early settlers frequently remarried after a spouse died. At a time when medical attention was not readily available, people did not always live through injuries from daily chores and childbirth. Long-living survivors remarried, often more than once. In a small community, relationships sometimes became complex.

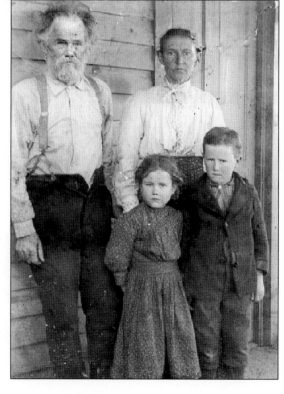

Joe McKinney and Family. Joseph, son of Charlie McKinney and Margaret "Peggy" Lowery, was born around 1840. He was nicknamed "Jippin' Joe" to distinguish him from his brother, Joseph Tarpley McKinney. "Jippin' Joe" was a Confederate soldier. He married Mary Biddix in 1853, and after Mary's death, he married Emeline Roberts in 1889. He is shown here with Emeline and their son Samuel V. McKinney. The little girl is unidentified.

ELMIRA CHRISTINA McKINNEY RATHBONE CODY. Elmira, the daughter of Charlie McKinney and Nancy Triplett, was born in 1837 and died in 1912. She married Thomas Richmond Rathbone and had three sons. Thomas served in the Civil War for one month before he died of measles. She had two more sons, but would not identify the father, and then married William Anderson Cody. Elmira left Cody and moved in with her daughter-in-law, Hanna Joanna Rathbone. Granny Elmira slopped the hogs, sat by the fire in a rocking chair and hummed, smoked a corncob pipe, and wore britches while she gardened, much to the dismay of her daughter-in-law, Hanna.

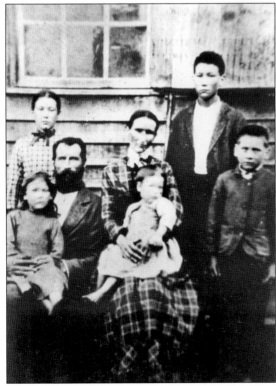

MARY McKINNEY. Mary, daughter of Merritt and Susannah, was born in 1856 and married Calhoun Hall, beginning a long line of Halls in the Altapass area. Their children were Plato, Lockie, Yancey, Nora, and Edward.

17

THE DEWEESE SISTERS. Sisters Mary Deweese Biddix, born 1842, and Nancy Deweese Buchanan, born 1841, were daughters of Rachel McKinney Deweese, one of the two children of Charlie McKinney and Elizabeth Lowery. Mary, on the left, was the matriarch of the sizeable Biddix family of Altapass. Nancy, on the right, was called "Mother of the Mountain" in Little Switzerland. She is buried in a small graveyard on the grounds of the Switzerland Inn.

A COW STORY. Rachel McKinney married Louis Deweese in North Carolina, and they moved to Missouri, taking a cow with them. While in Missouri, Louis passed away, and Rachel decided to bring the girls (above) back to Altapass. She left the cow with neighbors in Missouri. After they got back to Altapass, the cow came back to them, all the way from Missouri, on her own. She would have had to swim across the Mississippi River. The photo at right is of Rachel's daughter, Mary Deweese.

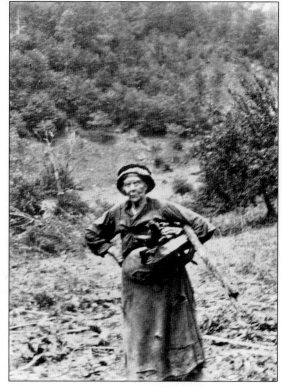

VANCE AND MCKINNEY FAMILIES. The Vance Tunnel, on the Altapass Clinchfield Railroad line, was named after the family of Robert Vance. He is pictured here with his wife, Mary McKinney Vance, daughter of Winfield Scott and Mary McKinney.

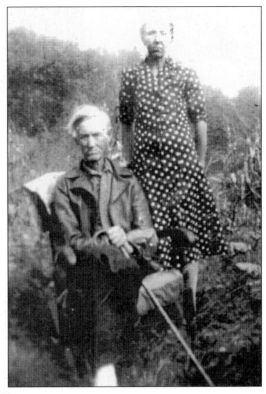

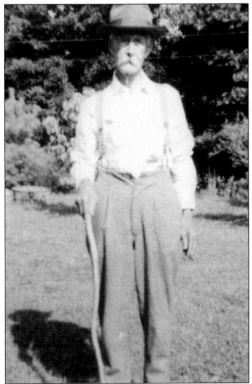

JUDGE CHARLIE SCHISM. Judge Schism was the assistant postmaster at Altapass in the late 1930s or early 1940s. His family arrived in Altapass around 1900. He married Nora Mathis Schism, the grandmother of Little Switzerland's present postmaster, Jesse Mathis.

19

NANCY QUEEN. Nancy was the wife of George Queen and the mother of the three Queen brothers, who were popular musicians around Altapass. Inside the door is Bonnie Riddle, daughter of Tilden McKinney and Rosanne Bryant. She lived in Humpback most of her life, but earlier she lived briefly at Construction Camp Two on the railroad. The Riddles, Wisemans, and some McBees are her descendants.

SAMUEL NELSON BIDDIX FAMILY. Samuel Nelson Biddix was the son of Mary Deweese and Francis Biddix. He was born in 1874 and died in 1957. He married Rosa Williams, seated next to him in this photo. Children (not in order) are Carrie, Stacy, Willie, Mose, Vennie, Lennie, Aaron, and Forrest, who died young.

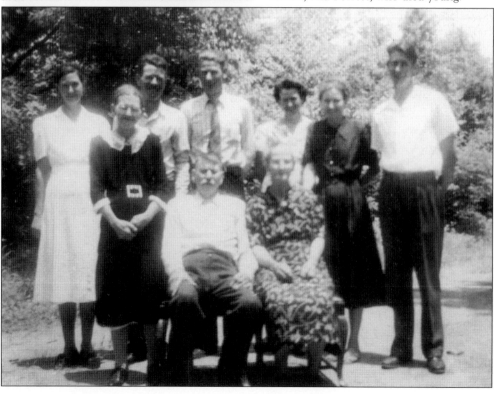

WILMA ELLIOT AND BELLE SULLINS. The child on the top right is unknown. Wilma Elliot is at top left. Her father was a music teacher who taught shape-note singing. Belle Sullins, in front, was the daughter of Joe Sullins and Cora Chapman Sullins. Carter Sullins was Belle's brother, and Judy, Pat, and Tony were his daughters. Judy Sullins married Jack Harris, the great-nephew of Lydia Holman.

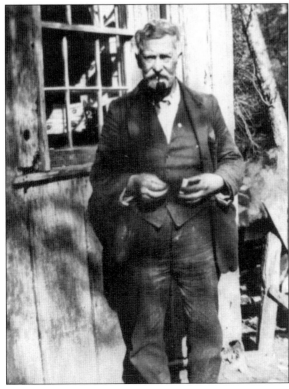

"POP GLENN." David Monroe Glenn was a Civil War veteran with Company 1 of the North Carolina 11th. He was the father of the Glenn brothers, who ran the hack that carried passengers to Little Switzerland from the Switzerland Station near Altapass for the Switzerland Land Company. He was the great grandfather of Virginia Glenn Biddix. "Pop" was born in 1845 and died in 1939.

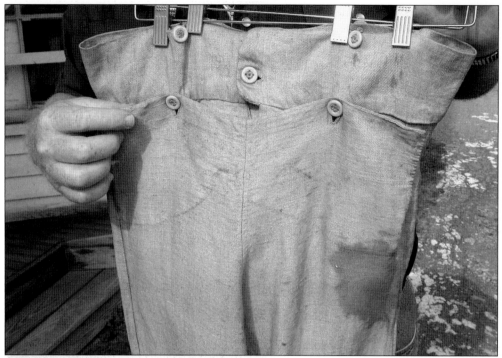

THOMAS MCKINNEY'S PANTS. These tobacco-stained trousers belonged to Thomas McKinney over 200 years ago. The pants are on display at Ruth Houston's Sunny Brook Store.

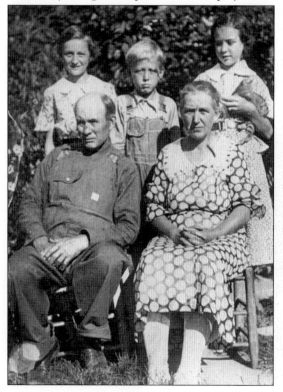

JASON MCKINNEY. Jason was the son of Sevier McKinney and Betty Carver and grandson of Merritt. He was born in either 1881 or 1889. He and his wife, Jennie Dolan, were married in 1909. The children behind them in the picture are their twin daughters, Nancy and Caroline, and son Will. Son Dana is not pictured.

Jane Biddix Washburn. Jane was a great-granddaughter of Charlie McKinney and Elizabeth Lowery. She was the daughter of the large family of Mary Deweese and Francis Biddix. The present Biddixes of Altapass are descendants of Mary and Francis. Mary was one of Altapass's pioneer women. The Deweese girls are said to have Native American ancestry on their father's side. Their mother, Rachel, married Alexander Lowery in 1850, when Mary was six years old. Rachel was 36 and Lowery was 19.

Elmira McKinney. Elmira, called "Elminer," was born in 1834 to Charlie McKinney and Margaret "Peggy" Lowery. She married Merritt Calvin Biddix and had five children. She died in 1904 and was buried in Grassy Creek in Mitchell County.

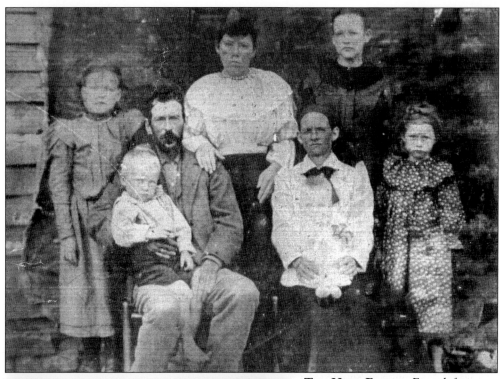

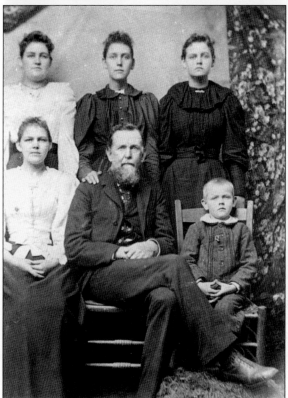

THE HALL FAMILY. From left to right are (front row) Zeb V. Hall with Zeb V. Hall Jr. in his lap; Emily McKinney Hall with Pearl Hall Pritchard in her lap; and the future wife of Clyde Pritchard; (back row) Etta Hall Wiseman, Will's wife; Cordie Hall Swofford, Ira Swafford's wife; Lula Hall Vance, Willard Vance's wife; and Bertie Hall Franklin, Kelly Franklin's wife. Zeb Hall died before James G. Hall was born. Zeb was a brother to Calhoun Hall, Plato's father.

GEORGE ELISHA GREENLEE FAMILY. The small boy in this photo is Thomas Samuel Greenlee, shown on the top of the next page. His family was, from left to right, (front row) Etta, George Elisha Greenlee (the father), and little Samuel; (back row) Ada, Ida, and Eva. George inherited land from the original part of the John Carson tract from his father. He also fought in the Civil War as a private.

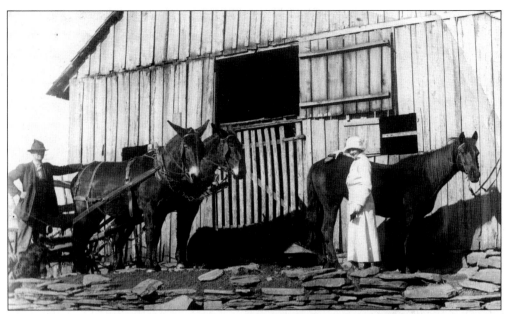

THOMAS AND AMELIA GREENLEE. Thomas Samuel Greenlee and Amelia Meares Greenlee, for whom the Greenlee School in Spruce Pine was named, tend to horses on their farm. Samuel was the grandson of Jane McKinney. Merritt and Susannah McKinney's daughter. Samuel lived in Mitchell County all of his life and ran a picturesque gristmill that was torn down when Highway 226 was built at Spruce Pine.

STUDENTS NOMINATE NORTH CAROLINA MOTHER OF THE YEAR. Amelia Meares Greenlee came to the area in 1913 to teach at the Presbyterian Mission school in the Grassy Creek Presbyterian Church. She married Samuel Greenlee in 1914. In 1947, the students in Amelia's class nominated her as the North Carolina "Mother of the Year." *The Tri-County News* reported in an article appearing April 17, 1958, "For 29 years children of the community had the privilege of going through her grade and not one ever forgot her radiant personality and encouraging smile."

25

THE OVERMOUNTAIN MEN. On September 25, 1780, over 1,000 untrained volunteer soldiers mustered at the Sycamore Shoals of the Watauga River in current-day Elizabethton, Tennessee. They crossed the high mountains and dropped into the North Carolina Piedmont pursuing Maj. Patrick Ferguson and his Tory army. They finally caught them on October 7 atop Kings Mountain, South Carolina. President Carter recognized the historical significance of the Campaign to Kings Mountain by signing a law designating the route the Overmountain Victory National Historic Trail. In the photo, Grant Hardin reenacts the part of a British officer.

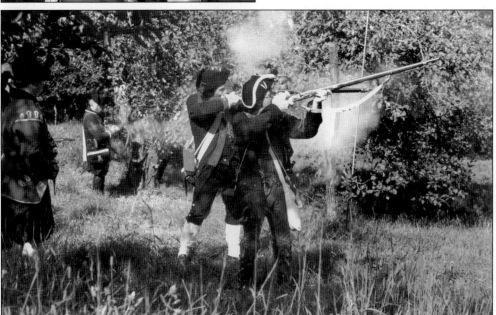

MARCHING THROUGH ALTAPASS. The Overmountain Victory Trail runs through Altapass. Every year, the march is reenacted by volunteers in authentic period dress who follow the original trail as closely as possible, stopping for the night near the spot the original marchers rested. Every September 28, they march along the trail through the property of Sunny Brook Store and then to the graves of Robert Sevier, brother of John Sevier, and early settler Martin Davenport on Unimin Corporation property.

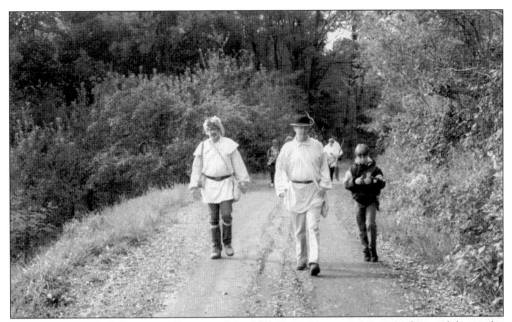

REENACTMENT IN MITCHELL COUNTY. Mitchell County community members celebrate the reenactment by providing hot meals for the marchers. They are rewarded with dramatic storytelling by reenactor Mike Dahl. In 2003, Jill Carson donned period dress made by students at Penland School as a research and textiles project. The reenactors present historical sketches and demonstrations for school children and community groups along the way. Above, schoolchildren join the marchers on the road through the Altapass orchard.

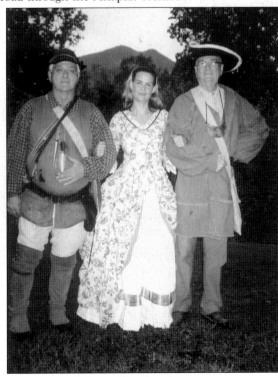

PERIOD DRESS. Mike Dahl (left), Jill Carson, and Bill Carson bring to life the time period of the Revolutionary War with carefully re-created period dress. Mike Dahl made the outfits for both men.

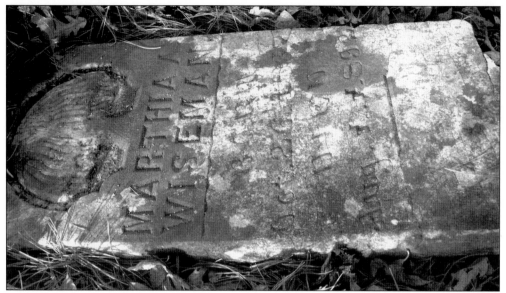

GURLEY CEMETERY. The tombstone for Martha A. Wiseman lies in an overgrown hillside on private property. Tombstones often tell amazing stories and family histories.

DAVENPORT CEMETERY. The Davenport Cemetery is at the end of Davenport Road off of Altapass Road. The Revolutionary War hero Martin Davenport is buried near the grave of Robert Sevier on Unimin Corporation property.

Two

FROM TRAILS
TO TRACKS

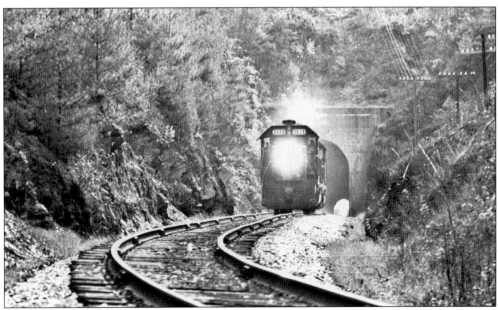

THE RAILROAD. A new era opens when the train comes through the Blue Ridge Tunnel bringing a load of opportunities to the community the railroad named Altapass.

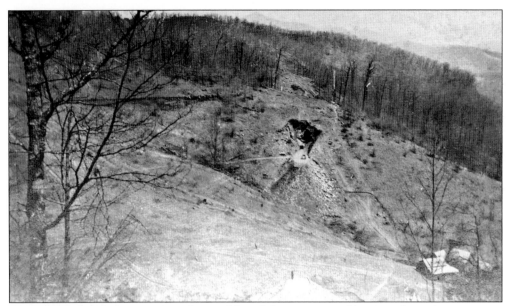

DYNAMITE! A new century sent the rumbles of dynamite reverberating along the mountain ridges. The CC&O Railroad began laying tracks along the incredibly rugged face of the Blue Ridge to establish a route for coal to be transported by rail from the mines of Eastern Kentucky to customers in the South. The lowest pass for 100 miles was McKinney Gap, at an elevation of 2,678 feet.

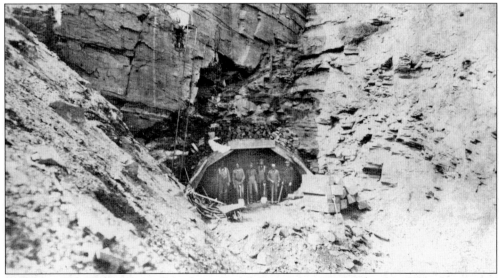

EIGHTEEN TUNNELS. Men with pickaxes and dynamite burrowed through solid rock to create 18 tunnels along 13 miles of track to make the bed for the railroad that switch-backed across the mountainside. The trains had enormous engines pulling hundreds of loaded cars along the face of the Blue Ride at a grade less than 1.5 percent. In 13 miles of track, the trains traveled only 3 miles "as the crow flies."

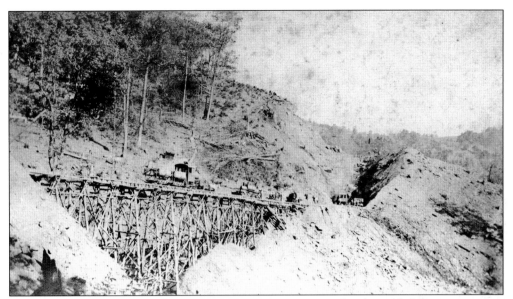

WOODEN TRESTLES. In order to move equipment across the face of the mountains to construction sites, workers built temporary wooden trestles topped with narrow-gauge railroad tracks. Dirt created by tunnel construction was dumped over the sides of the trestles until the wood structures were completely covered, creating a permanent solid roadbed for the railroad. The trains that worked on the trestles were smaller and lighter than the mainline trains that would utilize these tracks well into the next century.

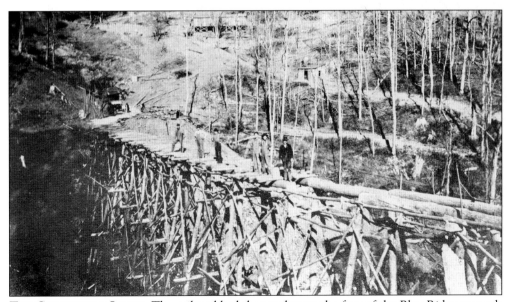

THE CLINCHFIELD LOOPS. The railroad bed that snakes up the face of the Blue Ridge to reach isolated mountain communities is now called the Clinchfield Loops. Upon completion, it was know as the engineering marvel of the 20th century.

Work Camps. Seven work camps housed hundreds of workers in temporary construction shanties. Sherman Washburn, a major landowner in the area, sold right-of-ways to the railroad across his farmland. The three Washburn tunnels were named after the Washburn family. Other local residents along the construction zones were James Calhoun Hall; Jim Houpe, who ran the commissary and post office at Camp 4; Monroe Lowery; and Samuel Hensley, a railroad worker. Hensley's expertise was an important part of the railroad's success. This photo shows "Uncle" Daniel Washburn's house and Camp 4.

Camp Four. In 1909, the major railroad work of Camp 4, pictured here, was completed. The Switzerland Company purchased the buildings for $138 and used them during the construction of the Etchoe Pass Road (now Route 226A) to provide access to the young community of Little Switzerland. The camp included a commissary, sleeping quarters for workers, a blacksmith and carpenter shop, and a post office.

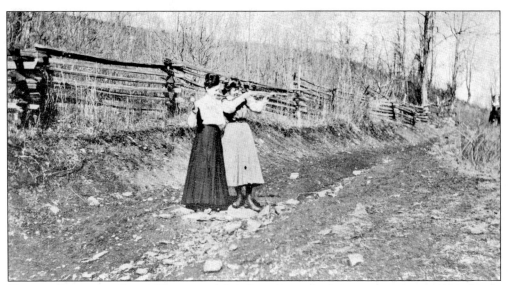

TARGET PRACTICE. Grace Privette and Iris Quinn try a little target practice on their family farms along the construction areas. Mountain women worked for the railroad, cooking and providing laundry services. Some families purchased railroad shanties for homes, but eventually the shanties were all torn down.

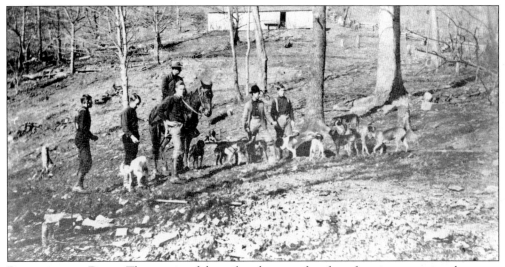

RUNNING THE DOGS. The terrain of the railroad was perfect for a favorite recreational sport— fox hunting. The men of the community built campfires and cooked up coffee, potatoes, country ham, cornbread, and onions, then released their dogs to search for the scent of foxes. When the dogs found a scent, their barks turned to bays. When an owner recognized the bay of his own dog, it was music to his ears. The important part of the hunt was to demonstrate the prowess of each dog, not to capture foxes.

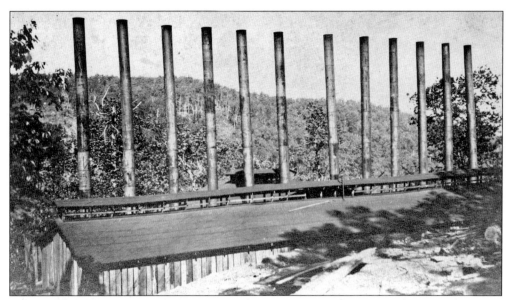

AIR COMPRESSOR. This huge steam-powered air compressor was one of the most important machines for railroad construction. Fired by wood, it powered all the dynamite drills used to blast the tunnels. Drilling with dynamite was extremely dangerous. The Blue Ridge Tunnel was drilled from both ends until the holes met in the middle. A blast from one side accidentally opened into the other and killed many workers. The compressor also produced the first electricity in Altapass around 1905.

DINKY LINES. Dinky lines utilized small, narrow-gauge work trains to bring men, supplies, and equipment to the construction sites. A line from Altapass Station to Camp 4 and a line from Altapass to Honeycutt Mountain ran between railroad loops and brought supplies to more than one camp.

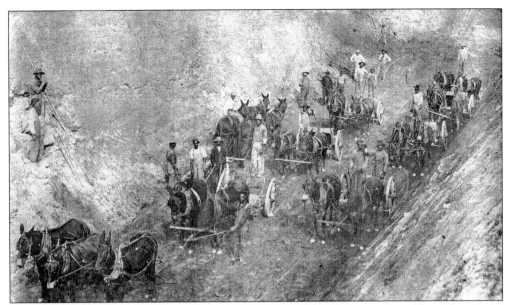

SCRAPERS. This unusual photo shows horses pulling the large flat pans that scrape the railroad bed, picking up dirt and rocks from high places and depositing them in low places. The work is much like the work of bulldozers. The CC&O imported more than 4,000 men to do the backbreaking labor of taming mountainsides for railroad tracks.

UP THE GAP. A steam shovel works its way to the summit of the gap. The railroad was opened between Dante, Virginia, and Spartanburg, South Carolina, in 1909 at the completion of the Clinchfield Loops. The final 35-mile segment from Dante to Elkhorn, Kentucky, was completed on February 9, 1915. The first passenger train to travel the full length of the rail line occurred in July 1915.

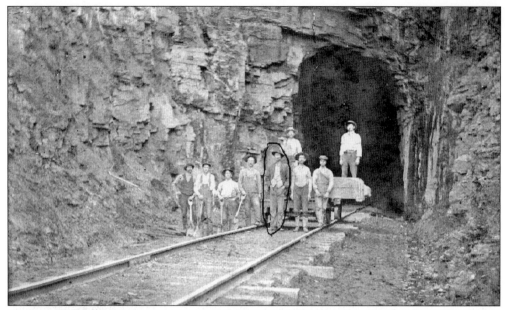

TUNNEL WORKERS. Only two members of this tunnel-digging crew are identified. Third from the left is Bob Mace, and the tall man standing next to him is John Robert Hollifield.

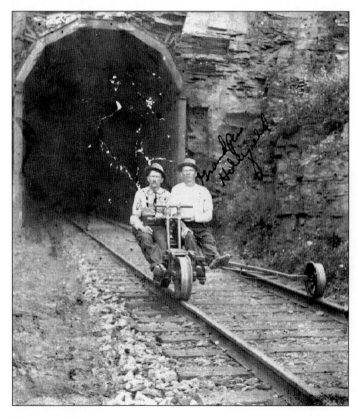

HITCHING A RIDE. Charlie Fox and Garfield Hollifield head out of a tunnel on a railroad handcar c. 1900.

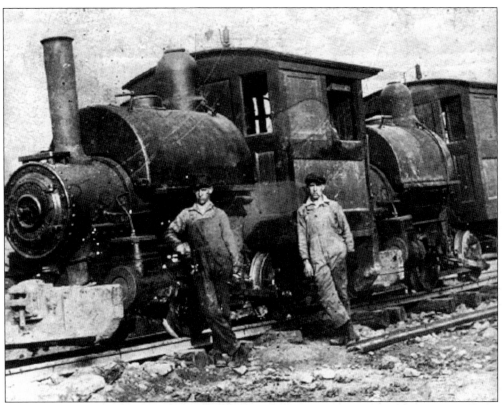

TWIN DINKY TRACK ENGINES. Mose McKinney (left) and an unidentified friend lean against two South & Western unnumbered dinky track engines that rest at Altapass. These trains carried men and materials over the Blue Ridge to camps on Washburn Knob and Honeycutt Cove. Later they worked Clinchfield construction sites.

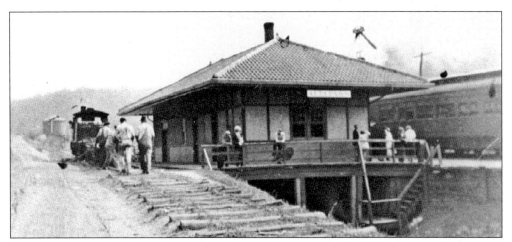

TWO TRACKS. This photo shows the Altapass Station with a passenger train on the main track on one side of the station and a dinky line track on the other. A creek ran right under the station.

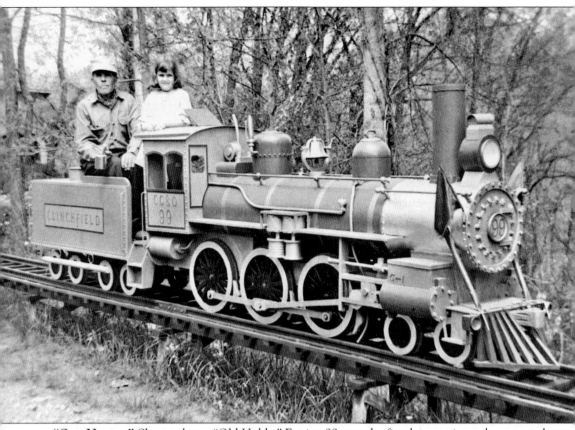

"OLD HULDY." Shown above, "Old Huldy," Engine 99, was the first locomotive to be operated on the Clinchfield Railroad through Altapass. Bakersville craftsman Frank Canipe created this wooden replica. He is pictured here with his great-niece, Kathy. Canipe took the train down a mountain near Red Hill with the children piled in the coal car. Passengers helped manually push the train back up the hill after the ride. Oily rags were burned, and the smoke was pushed through pipes to the smoke stack. C.C. Morgan ran Old Huldy from Johnson City to Altapass in March 1908. The engine was at the Johnstown flood of 1889, where she ran down the valley at 70 miles per hour warning the people in the path of the oncoming flood. In October 1910, a trainload of dignitaries made their first trip from Johnson City to Ashford. About two miles north of Ashford, a landslide had completely blocked the tracks for days, and the passengers had to walk a quarter-mile to get out.

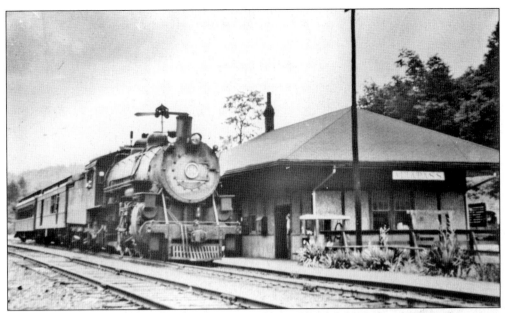

THE CLINCHFIELD ROUTE. The 309-mile route of the Clinchfield Railroad crosses five states, runs through 55 tunnels, and traverses elevations from 742 feet at Spartanburg, South Carolina, to 2,678 feet at the crest of the Blue Ridge Mountains. The construction of the Clinchfield established a precedent of tunneling rather than building low-grade roadbeds to circumvent rugged terrain. To accommodate heavy-tonnage coal trains through the mountains, the company burrowed wider tunnels, constructed easy curves, restricted all bed grades to 1.2 percent, and installed 85-pound rails, replacing the usual 60-pound rails.

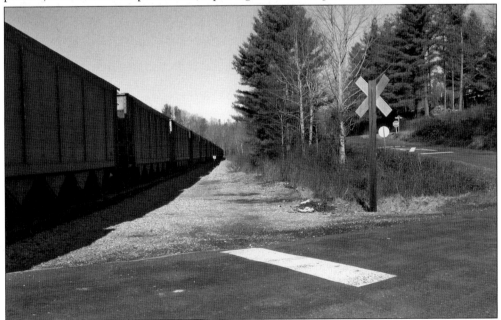

STATION SITE C. 2004. This photo shows the site of the Altapass Depot as it looks today. The landmark near the corner of Holman Hill Road and Altapass Road is gone, but trains still roll by on the original Clinchfield tracks.

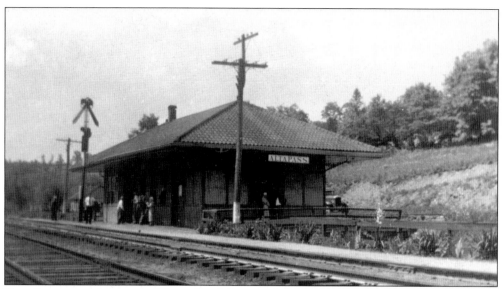

THE CENTER OF ALTAPASS. The railroad depot and the Company Store and Post Office were the center of Altapass in 1915.

POSTMASTER. Fonz Hefner, father of orchard manager Deward Hefner, was postmaster at the Company Store and Post Office when the parkway was being built.

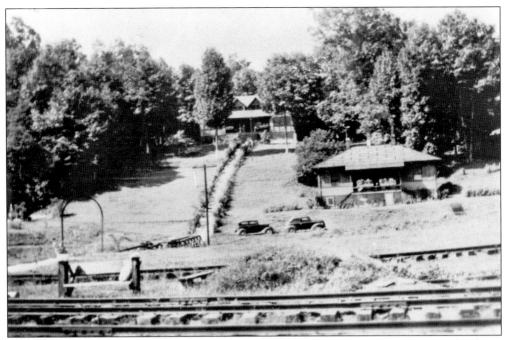

ACROSS THE TRACKS. Looking across the tracks from the Altapass railroad depot, the depot agent's house is on the right, and the Railroad Boarding House is in the middle background. The springhouse was located just out of the picture on the left.

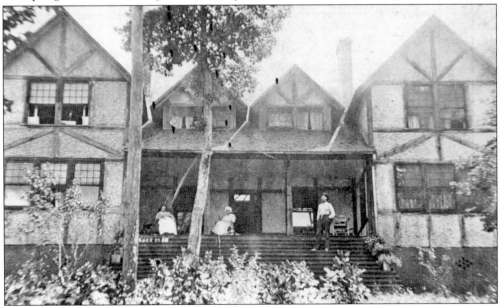

THE BOARDING HOUSE. When trains reached Altapass late, the engineer spent the night at the Railroad Boarding House. Station workers stayed with the engine all night, keeping the fires hot in the boilers so the train would be ready to continue the journey down the tracks through the Loops in the morning. Altapass historian Elvira Bryant recalls childhood days when her aunt took her to stay at the boarding house as a special treat. Relaxing on the porch are Claire Garland, Etta Hall, and Jim Hall.

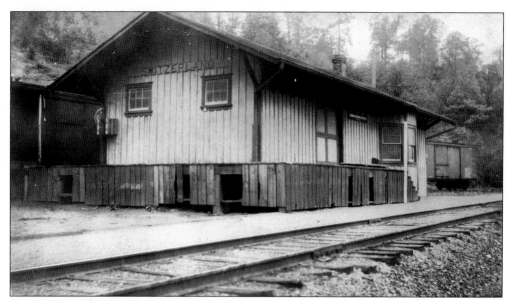

SWITZERLAND STATION. The Switzerland Station was originally known as the Mt. Mitchell Station, which was located on the south side of the Blue Ridge Tunnel near Altapass. Mr. Clarkson of Little Switzerland asked the CC&O to move the Mt. Mitchell station two tunnels closer to the Little Switzerland development. This put the station at the entrance of the First Washburn Tunnel, near Camp 4, just below Gillespie Gap. A few years later, the station was renamed the Switzerland Station.

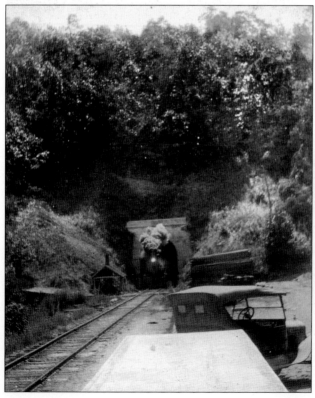

WASHBURN TUNNEL. The train nears the Switzerland Station exiting the First Washburn Tunnel, named for the Washburn family, who lived in the area and sold right-of-way land to the railroad. Three of the 18 tunnels on the Clinchfield Loops route are named for the Washburn family.

BOARDING HOUSE HOSTS. For many years, John and Carrie Hall operated the Railroad Boarding House, located on the hill across from the old depot at Altapass, not far from Lydia Holman's hospital and library.

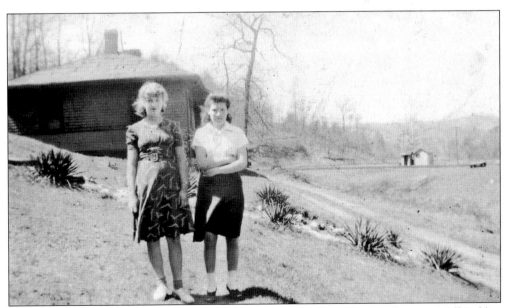

NEAR THE SPRING HOUSE. Marjorie and Jane Biddix, daughters of Jodi and Teavus Hall Biddix, are in the yard of the depot agent's house. The path leads to the springhouse in the background.

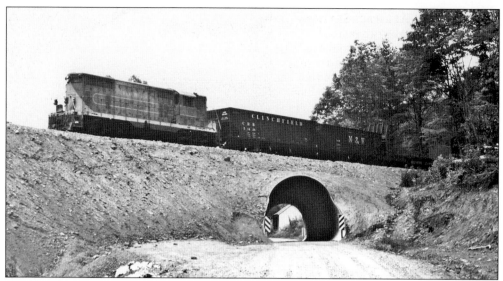

THREE KINDS OF TRACKS. The mainline brought the big trains that traveled from Spartanburg, South Carolina, to the coalfields of Elkhorn, Kentucky, carrying passengers and products to stations along the route. To bring products to the mainline from local factories, farms, and mines, the Clinchfield developed a series of spur-line tracks. This 1967 photo shows Engine 908 going down the spur after delivering lumber to the Henredon Furniture Factory. The smallest trains were the dinky lines used for logging and for taking materials to workers at construction zones.

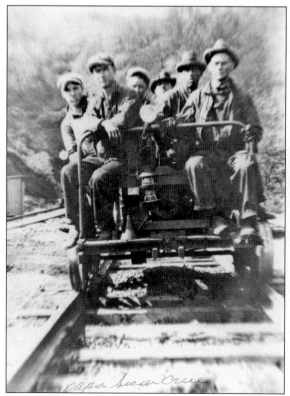

RIDING TO WORK. A section crew is riding on a railroad motorcar. From left to right are (front row) Sam McKinney (grandson of Merritt McKinney) and Steve McKinney; (back row) Howard Hall, Fred McKinney, section foreman Robert Biddix, and Andy Ballard.

TUNNELS NEAR ALTAPASS STATION.
Altapass is flanked by two railroad
tunnels: Blue Ridge Tunnel to the
south and Vance Tunnel to the north.
This photo was taken from above the
Blue Ridge Tunnel, just below the Blue
Ridge Parkway. Until late 1979, Ridge
Siding ran right below Altapass Ridge.
In steam days, it had a coal tower and
water tank right below the apple
orchard. Ridge Siding was replaced in
1979 by the longer Toe River Siding
just north of the Vance Tunnel.

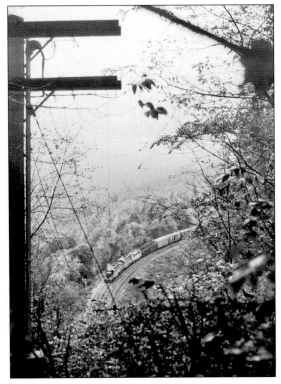

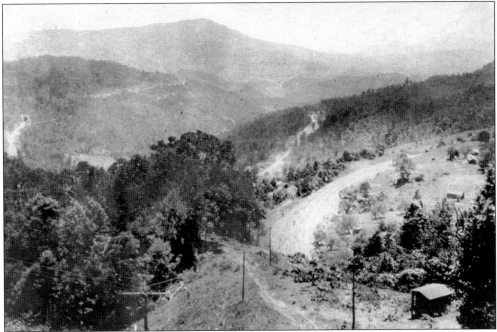

SAME SCENE. The photo above is the same scene taken from the same spot around 1920. The
Blue Ridge Parkway was not yet built. It shows the earlier passing siding. It also shows houses
in the lower section of the apple orchard at the north end of the loop. On the left the tracks
can be seen looping back, heading for Rocky Mountain.

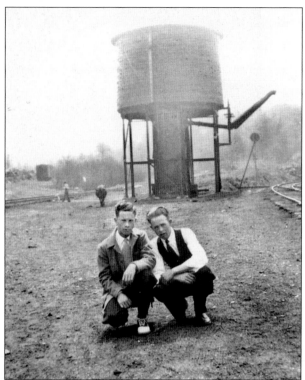

THE WATER TANK. Jim Benfield and James Graybeal pose in front of the Altapass Station water tank. Tanks like this one were placed frequently along the tracks, providing a vital component to steam engines. In the background, J.D. Hefner is bringing in a cow. Jack McKinney remembers enjoying swimming parties in this water tank when he was a boy.

TRACKS ON ROCKY. The railroad line is visible along the lower edge of the mountain appropriately named Rocky. This photo was taken in 1957 from the Clinchfield Loops overlook on the Blue Ridge Parkway above the Orchard at Altapass. The railroad planted the old orchard *c.* 1910.

TUNNEL VISION. Jeanette Long is waiting to see a train come through the Vance Tunnel on the north side of Altapass Station. Jeanette is the sister-in-law of Doug Long of Concord, Ohio, who took pictures of the Clinchfield line at Altapass from 1957 to 1992.

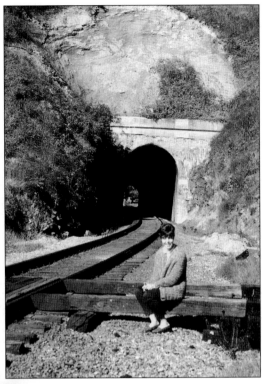

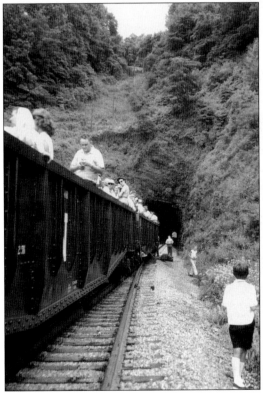

ENJOYING THE COLORS OF FALL. Excursion trains carried sightseers from Erwin, Tennessee, to Marion, North Carolina, in the spring and fall to show off the beauties of the Clinchfield Railroad line. In 1958, riders had photo-ops from open gondola cars. The train is about to enter the Blue Ridge Tunnel on the south end of Altapass.

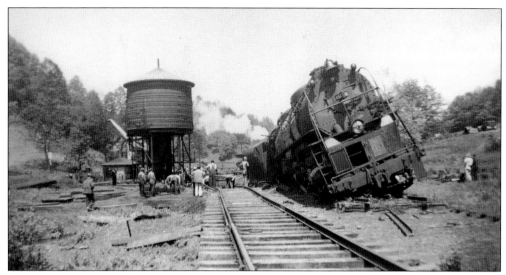

TRAIN WRECKS. The Clinchfield southbound train from Altapass, the heaviest engine on the line, went off the main track onto a side track designed for loading apples from the orchard on light-weight local trains. The trestle was not strong enough to support the big train, and 17 cars derailed. During World War II, the Clinchfield began employing women as stationmasters. Rumors flew that someone intentionally threw the switch to discredit Mary Letterman in her job, but Mary was cleared of any charges and went on to serve more Clinchfield stations.

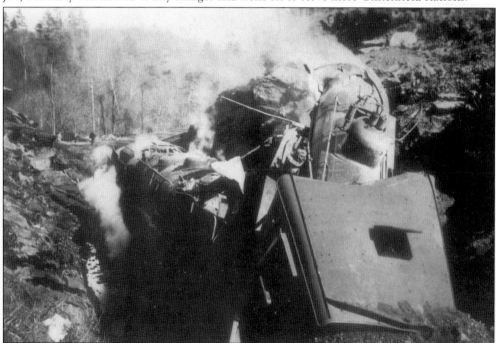

THE TRAGEDY AT BERRY GAP, 1932. Passenger Train 38 left Erwin, Tennessee, heading south. Everything went well until it came to Berry Gap, two miles above Spruce Pine. At that same moment, a coal train pulled out on the main line at Altapass, heading north to Erwin. Claude McClure, the station agent at Spruce Pine, jumped in his car and tried to stop the passenger train. The two locomotives collided at 75–80 miles per hour.

Three

THE RAILROAD
BROUGHT . . .

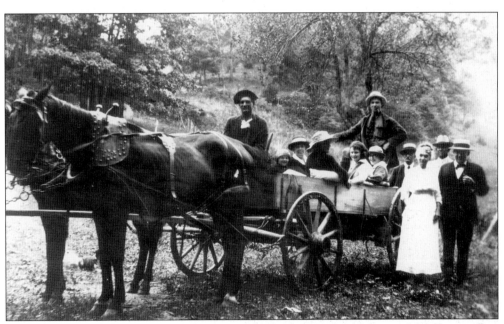

HIGH PASS. The railroad named the town Altapass, meaning "high pass." McKinney Gap was the high pass on the railroad and the low pass on the Blue Ridge. The CC&O hoped to attract people to the mountains in the summer months to escape the heat, humidity, and mosquitoes of the Southern flatlands so they could add to their railroad clientele. Early tourists crowd Joe Sullin's excursion wagon to be shuttled from the railroad to hotels and other places of interest, c. 1915.

AGENT FOR HOLSTON LAND CORPORATION. J.S. Bowen was the agent of the Holston Land Corporation, subsidiary of the Clinchfield Railroad, and managed most of the local ventures of the company. He was the manager of the Holston Orchard (now Orchard at Altapass) in 1916, when a great flood devastated the area. Two hurricanes lashed the eastern slope of the Blue Ridge a week apart. The first dropped 10 inches of rain in one day at the orchard, saturating the land, then moved quickly on. The second came from the southeast and stalled at Altapass. Bowen measured the rainfall at the orchard with a small rain gauge, which he patiently emptied day and night, getting the only accurate measurement of the rainfall. He measured 22.22 inches, setting an American rainfall record at the time for a 24-hour period. For 13 years, Bowen managed the Altapass Inn, was superintendent of the Holston Orchards, and had charge of all the Holston's holdings in Altapass, except those relating to the railroad itself. He acted as a promoter for the inn and the orchard and as the real estate agent for both, and he prepared reports assessing the values of holdings at the properties. He was even assigned the job of selling the mules belonging to the corporation.

THE HOUSE J.S. BUILT. J.S. Bowen built this house for himself and his wife. He died in the house in 1926. The home later belonged to Lee and Lennie Medford. The Medfords' grandson, Vince Hefner, recalls a night in this house when he was five; he woke up and saw the closet door open and a chilling gray cloud come out and stop over his sleeping father. It moved over him before disappearing. Years later Vince saw the picture of J.S. Bowen shown on the previous page—he knew right away that the childhood ghost was Bowen. Recently, at her home in Marion, Vivian Medford Harris (Lee and Lennie's daughter) awoke to see Bowen standing at the end of her bed.

THE BARN. Bowen's barn still stands near the house. The home and barn are on a ridge that overlooked the Altapass area in the 1920s. In the early days of Altapass, much of the vegetation was cut and used for building and firewood. Today, the area is heavily wooded, blocking the view of Holman Hill and the railroad tracks from the Bowen-Medford property.

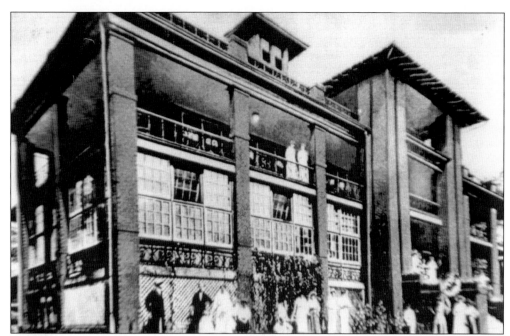

THE RAILROAD BROUGHT THE ALTAPASS INN. The inn was a seasonal hotel constructed on a hillside near the railroad depot around 1916 by the Holston Land Company, a subsidiary of the Clinchfield Railroad. It was one of the earliest accommodations for tourists in the area, with space for 150 guests. Elaborate brochures described the nine-hole golf course, a fresh water supply from high mountain springs, electric lights, modern plumbing, an orchestra providing live music throughout the season, dancing, billiards, and trap shooting.

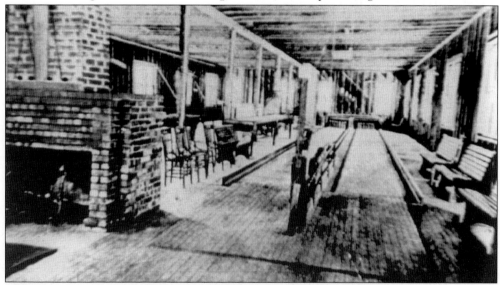

LUXURIES. The first of the three levels of the inn housed a bowling alley. The dining room offered "only the purest inspected dairy milk, cream and butter. The choicest vegetables were supplied in abundance from Altapass gardens and fruits from the Company's orchards and vineyards were choice and plentiful." The hotel provided resident physicians, and no one with throat or tubercular troubles was admitted.

THE FIRE AT THE ALTAPASS INN.
Decima Meredith McKinney told
this story in *Stories Worth Telling*.

When I was little, we used to
go around the Altapass Inn
and peek in the windows to see
what a big resort hotel was
like. . . . Some [guests] were
planning on going horseback
riding and they wanted me to
watch the children. . . .
Someone come out and said,
"Fire!" So they took me and
the children up on the hill up
behind the hotel. . . . [They]
said it was burning, and they
couldn't stop it. People come
carrying out furniture and stuff.
My younger sister come up and
said to me, "Mama's worried
about you!" I took off, I didn't
even worry about them babies.
She stayed with them.

BUS SERVICE. In the early 1920s, Brack
McKinney drove the bus that transported tourists
from the railroad station to the Altapass Inn.
Brack married Decima Meredith, above. The inn
burned to the ground on May 18, 1926, less than
a year after it was sold to S.T. Reid of
Spartanburg. The loss was $60,000. The inn had
no fire-fighting equipment. It was a major loss for
the community of Altapass.

THE RAILROAD BROUGHT TWO APPLE ORCHARDS. The Holston Land Corporation evaluated the south slopes of the Blue Ridge Mountains as a most favorable climate and soil for raising apples. The railroad bought the land that is now the Orchard at Altapass and planted apple trees around 1910. A note on the back of this photo says, "Look good and you can see the path that leads across the mountain and Aunt Em's field and the little hut. Also you can see Con's [McKinney] field and the fields above Floyd's [Hefner]." The company also owned the orchard at Hefner Gap.

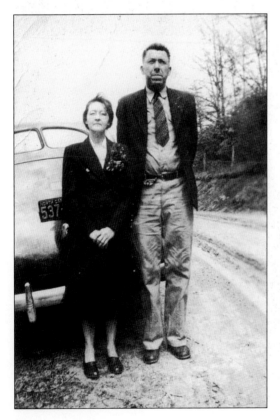

DEWARD'S YEARS. The heyday of the Altapass orchard was during the 30 years that Deward Hefner, with his wife, Blanche, managed the historic orchard from the 1930s into the 1950s. During the Hefner years, hundreds of local residents worked in the orchard. Many workers picked apples by day and drove trucks by night to feed their families. Altapass was no longer a farming community where people raised most of the things they needed; now residents worked for employers who shipped products by train to markets all over the country.

APPLE BUTTER MAKING. Gladys Saxon stirs up a batch of fresh apple butter. Gladys is the daughter of Decima and Brack McKinney. Apples were important commodities in the mountains. They were good for canning and drying, and making jelly, apple butter, and applejack. For drying, the apples were prepared in thin slices and put on the tin roofs of houses to dry slowly in the sun. Dried apples were particularly prized for mouth-watering fried-apple pies.

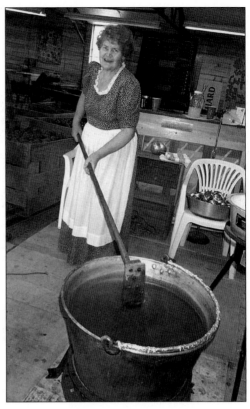

GRAPES. Ressie Roxanne Biddix stops to sample grapes in a one-acre grape vineyard at the Altapass orchard. The grapes were planted on a parcel of land where the Blue Ridge Parkway now passes above the present orchard. In addition to apples, in the early years of the Altapass orchard, peaches and grapes were planted at the upper side of the orchard. Fruit on the southern slopes on the Blue Ridge is protected from early frosts when temperatures drop.

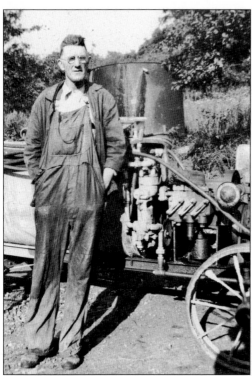

ORCHARD TASK. In the 1940s, Floyd Hefner made all the spray for the apple trees. He is shown here with one of the spraying machines.

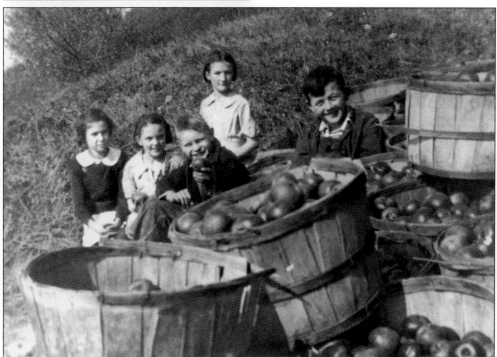

FIELD TRIPS. Even in the early 1930s, Altapass school children took field trips to the orchard. From left to right are Ocye Tolley, Meida Alaska Biddix, Harold Biddix, Geneva Biddix, and David Pittman.

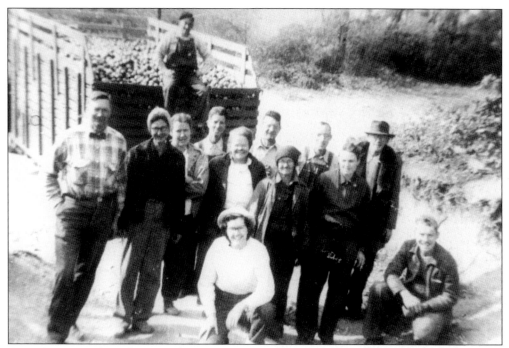

FALL CROP. Apple picking was long, tedious work, but many folks remember those days with joy. The apples were shipped out on the railroad and processed into juice, baby food, and applesauce. Shown here from left to right are (kneeling) Kathryn McKinney and Ray Ballard; (standing) Heb Washburn, Carrie Styles, Louise McKinney, Raleigh Hollifield, Loath Hollifield, Will "Teed" Biddix, Lora Jane Hefner, Claude Wiseman, Dorothy Styles, and Floyd Hefner; (on the truck) Oscar Biddix.

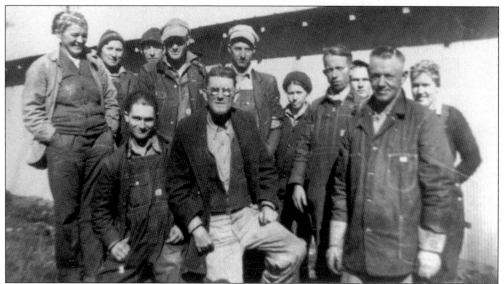

THE APPLE CREW. Shown from left to right are (front row) an unidentified woman, Floyd Hefner, and an unidentified visiting truck driver; (middle row) Belle Sullins, Clyde McKinney, Virgil McKinney, Jack Queen, and Louise McKinney; (back row) two unidentified, Gertrude Ellis, and Jack Williams.

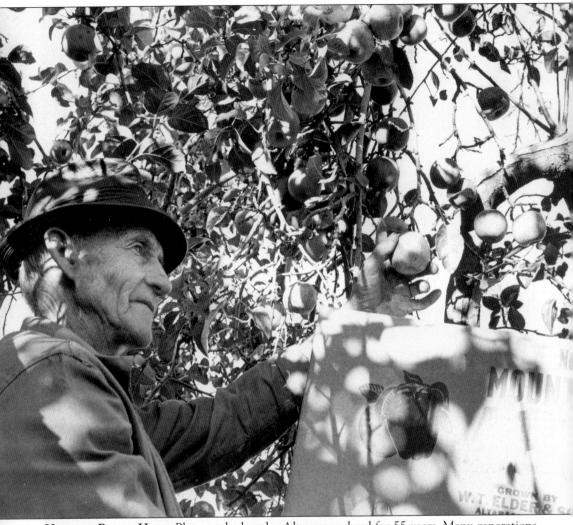

HERBERT PLATO HALL. Plato worked at the Altapass orchard for 55 years. Many generations of orchard patrons looked forward to visiting with lanky Plato, who greeted them with a ready smile and a twinkle in his eyes. He made thousands of friends during his half a century as salesman at the apple house. Plato always had a story ready:

When I was very small, I rode to Marion on a horse. I was seated behind my dad and my brother rode in a wagon with our hired hand, who was always full of mischief. We wanted to see the train in Marion, as I never seen one. When we arrived it was daylight, but as evening turned into darkness the train had still not arrived.

The four of us climbed upon a high wooden bridge so we could see the 'Great Iron Horse' as it pulled into Marion. Having never seen a train, my childish imagination was at an all-time high. Our hired hand announced, 'I see his one big eye coming.' I could see that yellow headlight coming toward us in the blackness of night.

Then our hired man said in a low, slow tone, 'Listen to him puff' and I could hear the engine puffing.

About that time the train's whistle gave a big blast and I jumped off my perch and ran scared to death, as fast as I could, away from my first view of the Iron Horse.

58

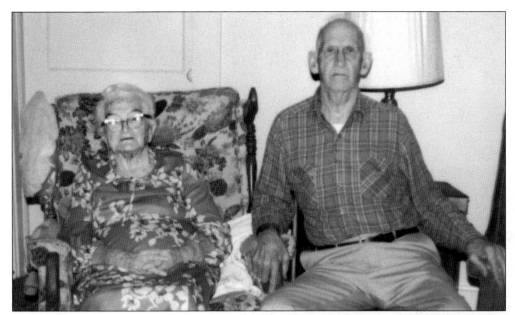

PLATO AND CALLIE HENSLEY HALL. The Halls were married almost 70 years. They raised their children, Oveda and Calvin, in the fourth-generation homeplace, built in 1884, where Plato was born. Plato's mother died when he was a child. In 1910, he and his father went to live at Camp 4, the settlement for workers building the railroad near Gillespie Gap. Plato's father established a general store, which also housed the Mt. Mitchell Post Office, where he served as postmaster.

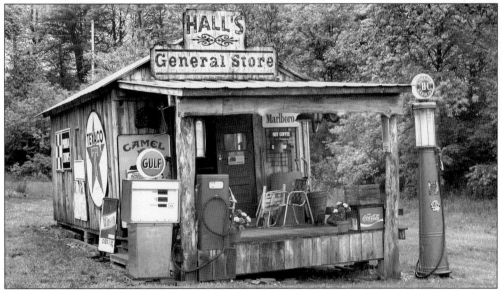

THE GENERAL STORE. Plato's father, James Calhoun Hall, built a general store on 50 acres in what was called the Halltown Community in 1880. As well as being a county surveyor and a farmer, he managed his store, which was probably much like the model of Hall's General Store at his grandson Calvin's outdoor museum. Merchandising was in the blood of Plato's family, as was farming. Calhoun Hall raised corn, oats, and potatoes on the family's farm, which is still home to his descendants.

THE KEYWADEN ORCHARD.
Geneva Biddix Mace, John
Graybeal, and Tincy McKinney
Gray enjoy a foggy day on the Blue
Ridge at the apple house on
Keywaden Orchard, at Hefner's
Gap. Today this orchard grows
Christmas trees.

ENJOYING THE ORCHARD. The orchard was a favorite place for people to meet. From left to right are (front row) Beatrice Hall, Ralph Biddix, and Helen Hall Byrd; (middle row) Graham Biddix (Valma Hall stands behind Graham), Geneva Biddix Mace, Faith Letterman Hefner, Wanda Hall, and Meida Alaska Biddix Mace; (back row) Jim Benfield, Rex McKinney, Ruth Hall Lowery, Fred Hefner, John Graybell (behind Fred), Hope Letterman Hefner, Della Biddix Hall, and Melissa Ardella Lowery Biddix.

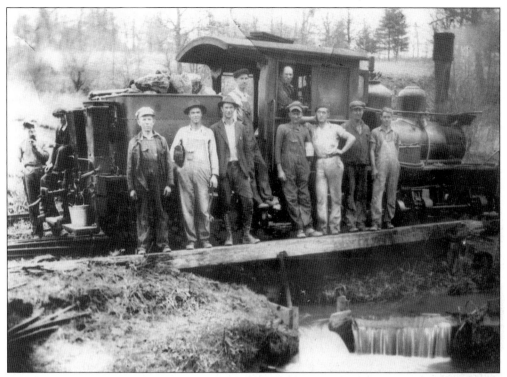

THE RAILROAD AT HUMPBACK MOUNTAIN. This 1933 photo shows the dinky line that ran to the Humpback Mountain timbering project. Workers are, from left to right, Frank McBee and Miller Pitman (behind the train), Jim Tipton, Lee Medford, foreman D.D. Kite, Cal Garland, engineer Jimmy Dolan, Edd Riddle, Jack Elliott, John McBee, and Vick Elliott.

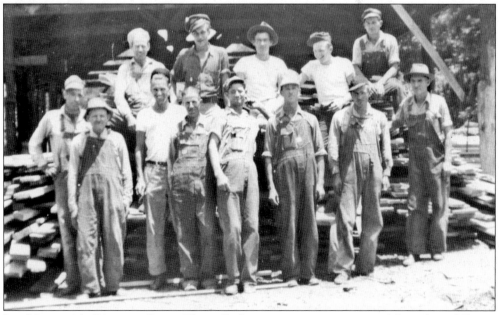

LEE MEDFORD'S SAWMILL CREW. The mill, during its existence, operated from three different power sources—steam, internal combustion engines, and finally electricity.

MELISSA ARDELLA LOWERY BIDDIX. Ardella was called "Lissy" by the community. She is in the photo below with her husband, Marion Robert Biddix, the railroad section foreman.

MARION ROBERT BIDDIX. Bob Biddix was a section foreman for the Clinchfield from 1924 to 1959. Bob and his wife, Lissy, are shown here in 1946. They lived in a railroad house next to the tracks close to the Altapass Depot. The road behind them goes up Holman Hill, where Lydia Holman had her hospital and library. As a young boy, Bob was a water boy for the crews constructing the railroad tracks.

A Sad Story. Ressie Roxanne Biddix holds her niece Marlene Robinson. Ressie was a daughter of Marion Robert and Melissa Lowery Biddix. She is standing in the Biddix yard among the flowers. Ressie was engaged but died shortly before her wedding from the influenza virus that hit Altapass in 1936. In the photo, she is wearing what was to be her wedding suit. Her fiancé, Earl Robinson, went on a journey with plans to return home and marry Ressie.

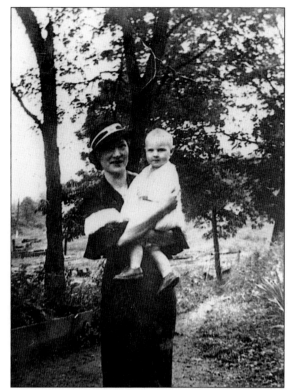

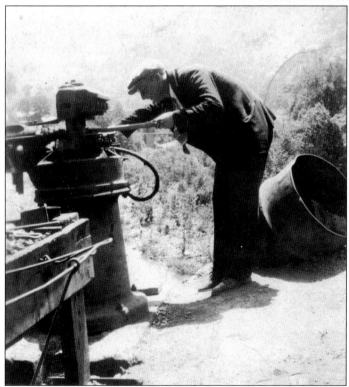

Bereaved Poet. When his sweetheart, Ressie, passed away while he was on a trip to the west, Earl Robinson, shown here, wrote this poem in her memory:
From her so many miles I wandered, far from my home in Caroline. I left the best, for that land in the west where they say there is always sunshine. But my blue skies were soon clouded with clouds without a silver lining. Since that message said, your sweetheart is dead, I'm so lonely and my poor heart is pining."

THE ROCK HOUSE. The striking grey Rock House stands up the hill from the Altapass Church of God. Today the area is used for revivals, retreats, Sunday school events, youth activities, and children's outings. This group of youngsters by the Rock House porch are, from left to right, (front row) Elaine Mace Lowery, Anita Carol, Marsha Dellinger, and Nicole Williams; (back row) Charles Fortner, Shawn Burleson, Greg Forbes, Christy Williams, Angie Ray, Dawn Carol, baby Becky Burleson, and Melody Forbes.

WATCHING THE TRAIN GO BY. The Clinchfield coal train passes Altapass on the way back to Kentucky. Ardella Biddix Hall (left) and Alaska Biddix Mace (right) bring children to hear the whistle blow. From left are Ardella's children, Joan and Rita, and Graham Biddix Jr.

THE 1935 CLINCHFIELD SECTION CREW AT ALTAPASS. From left to right are Fred McKinney, Lum Styles, George Pittman (standing behind Lum), section foreman Bob Biddix, Garford Pittman, and Milt Riddle.

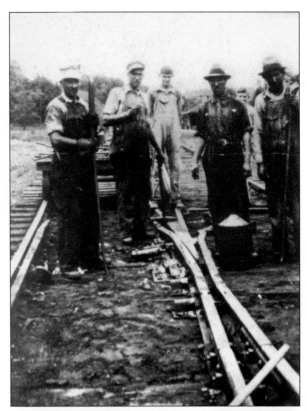

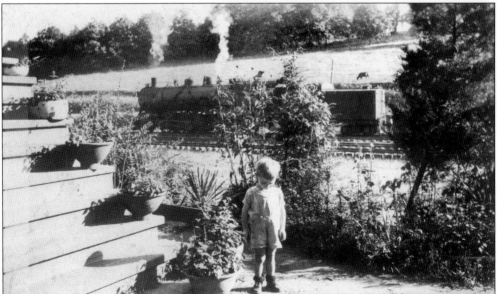

BLOOMS ALONG THE TRACKS. Graham Biddix, age three around 1935, is standing in the yard at the home of his father, Bob. The steps are filled with flowerpots. Ressie, Graham's sister, cared for flowers at home and at the depot and the railroad tool house in exchange for free passes on the train. The steam engine in the background was a local shifter. Cattle graze on Altapass Hill beyond the train.

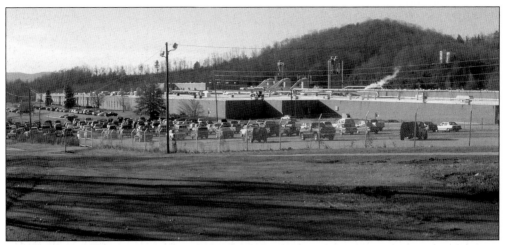

THE RAILROAD BROUGHT INDUSTRY. Henredon Furniture Factory was attracted to Altapass through the efforts of Lee Medford and Sam Phillips, providing jobs for many local workers. The railroad established a spur line to Henredon to bring lumber and supplies to the factory.

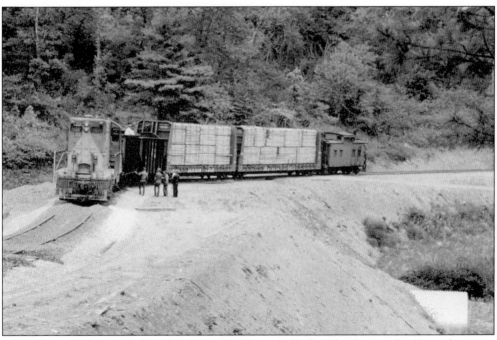

LUMBER FOR HENREDON. Local Engine 908 takes two loads of lumber up the Henredon spur, which opened in September 1967 and operated for three decades.

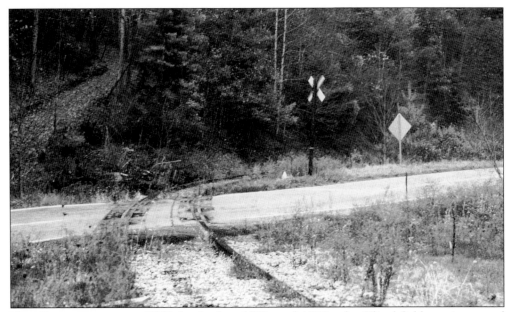

THE CLINCHFIELD AND CSX. In the late 1970s and 1980s, the Clinchfield was integrated into the "Family Lines" system that also included the Louisville and Nashville, the Seaboard Coast Line, and other smaller lines. Locomotives from any of these railroads could show up at Altapass. Thus began the demise of the down-home flavor of the Clinchfield. The Clinchfield no longer exists as such. The Altapass railroad is now another chunk of mammoth CSX. This photo, taken in 1992, shows the abandoned Henredon spur at Altapass Road, about to be torn up.

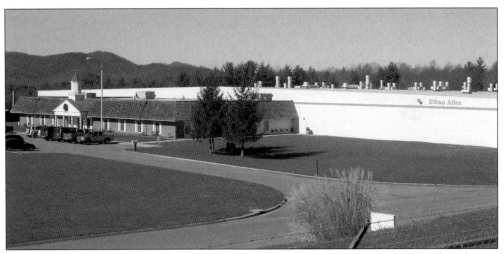

IN OPERATION. The Ethan Allen plant is one of the newest factories to be built in the Altapass area. As of 2004, it is still producing veneers for Ethan Allan furniture.

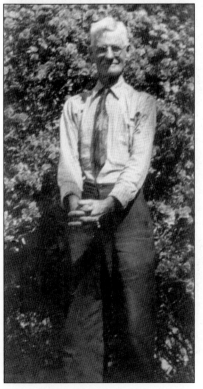

THE OLD HOME PLACE. This watercolor was painted 70 years ago by Ted Bowman, son-in-law of Willard and Lula Vance. It shows the early house on Halltown Road of Dick Vance's family, Bob and Mary McKinney Vance. Prior to living in this house, Bob and Mary lived in a cabin at the Altapass orchard, where their first child was born.

TOM VANCE. Tom Vance and his brothers, Bob and Willard, were sons of Samuel Vance. The Vance Tunnel was named after the Vance family. The railroad right-of-way passes through Vance land.

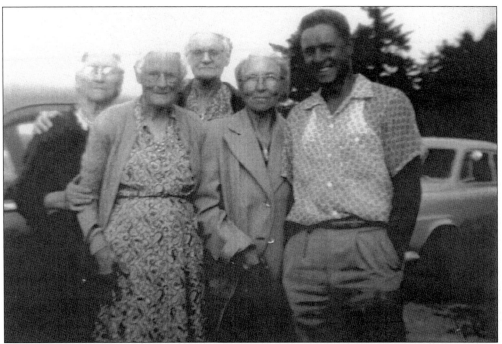

VANCE FAMILY. This *c.* 1930 photo shows, from left to right, Minnie Vance with May Vance Haynes, Magalene Vance Washburn, Mary McKinney Vance, and Douglas McKinney.

LONGTIME ALTAPASS FAMILY. The Vances were among the early names in Altapass and were kin to North Carolina governor Zebulon Vance. This watercolor was painted 70 years ago by Ted Bowman, son-in-law of Willard and Lula Vance. The painting now belongs to Dick and Cornelia McGee Vance. The painting shows the north end of the Clinchfield Railroad's Vance Tunnel, not far from the Altapass depot. In the lower left corner is Willard and Lula Hall Vance's old family farm.

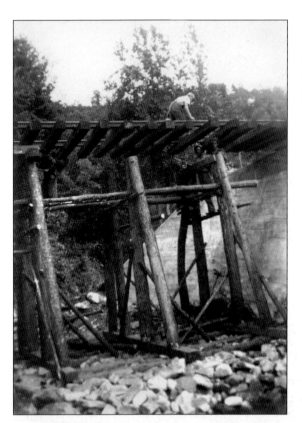

THE 1940 FLOOD. The flood of 1940 washed out many miles of the railroad track. Workers used poles to support this portion of the track next to the river until further repairs could be made.

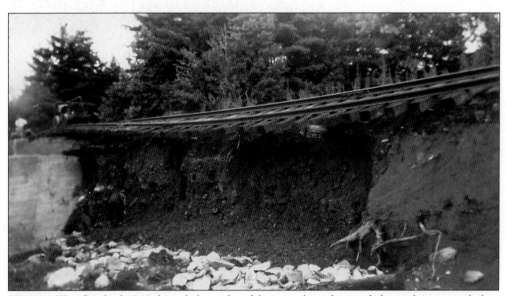

HAVOC. The flood of 1940 forced the railroad line to close down while workers struggled to shore up the tracks.

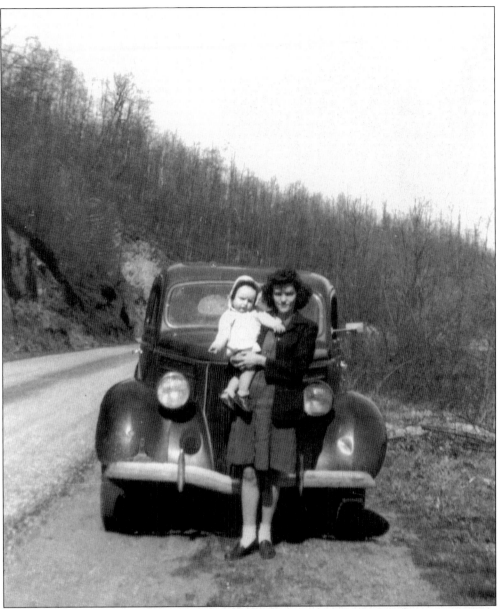

THE BLUE RIDGE PARKWAY ARRIVES. Alaska Biddix Mace, with baby Carolyn Mace, takes a spin on the new Blue Ridge Parkway sometime before the paving of the road was completed around 1961.

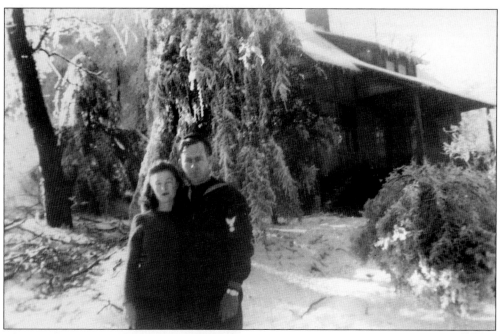

WINTER SCENE. Not many pictures were taken in Altapass in the wintertime. Geneva Biddix and William Glenn McKinney brave the icy weather at Geneva's family home.

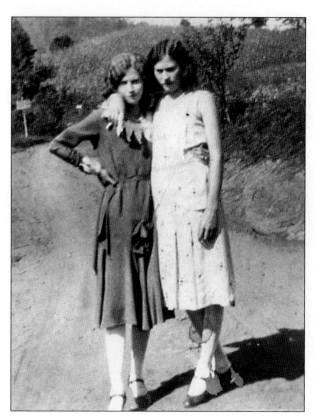

YOUNG WOMEN. Sisters Lennie Biddix Medford and Vennie Biddix Robertson are on the Old Appalachian Highway in front of Altapass Hill. Lennie and her husband, Lee Medford, are honored in the next chapter, "Living in Altapass."

Four

LIVING IN ALTAPASS

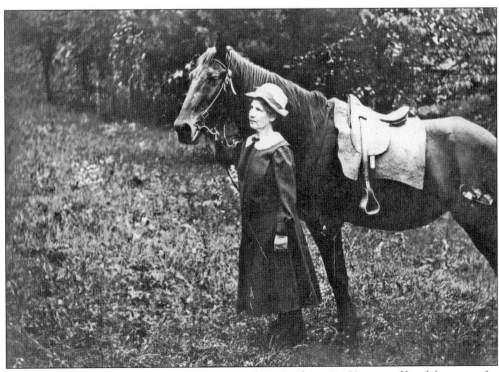

AN ALTAPASS HERO. Lydia Holman was a rural nurse who gave 58 years of her life to care for the people of Altapass, teaching them to lead healthier lives.

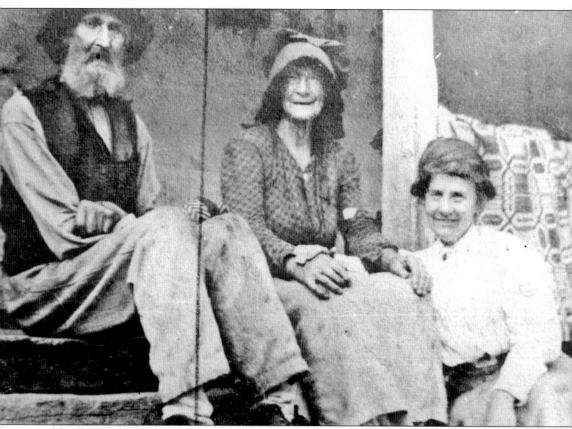

Missionary Nurse. Lydia Holman, pictured here (at right) with William Lafayette Phillips and Aunt Susie Phillips, was nurse, midwife, social worker, dentist, educator, and sometimes physician for hundreds of people in a 60-square-mile area. Born in 1868 in Philadelphia, she graduated in nursing from Philadelphia General Hospital in 1895. She served as a U.S. Army nurse in the Spanish-American War. In 1900, Holman nursed Mrs. J.J. Irvine, the former president of Wellsley College, in Ledger, North Carolina. Lydia became attached to the mountain folk and felt she could be of help to them. In 1902, she returned to the mountains to work as an independent rural nurse and welfare worker, available to the community on a "fee for service" basis. She also bartered her services for foodstuffs, household items, and gardening help. With the assistance of the Holston Corporation, Holman built a hospital to treat railroad workers and their families as well as to care for other Altapass families. The hospital included a delivery suite and operating room. In 1914–1915, Holman taught classes in sewing and canning and held kindergarten classes for the children. She fought epidemics of smallpox, chicken pox, scarlet fever, measles, and camp itch and held an immunization campaign to eradicate typhoid. She distributed toothpaste and brushes while teaching the importance of dental health. Holman spent many hours caring for the needs of women and children. Around 1920, she was arrested for practicing medicine without a license. The men of the community came to her rescue, and "20 men or more" took credit for having the case thrown out of court. Lydia Holman died in 1960 at age 92 and is buried in Spruce Pine Cemetery.

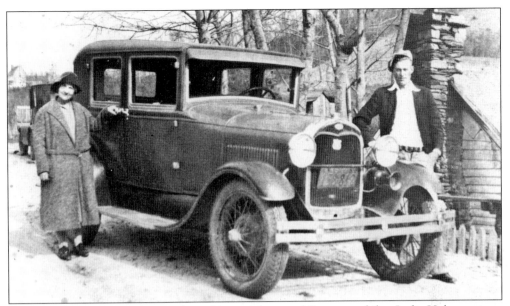

THE HOOVERMOBILE. When roads in Altapass improved for automobiles, Lydia Holman wrote to the Hoover administration and asked for a car so that she could more easily reach patients and take people to vote. Her request was granted, giving Lydia one of the first automobiles in the area. Her driver was Feller Lowery. Lydia never did drive a car herself. She usually traveled by horse.

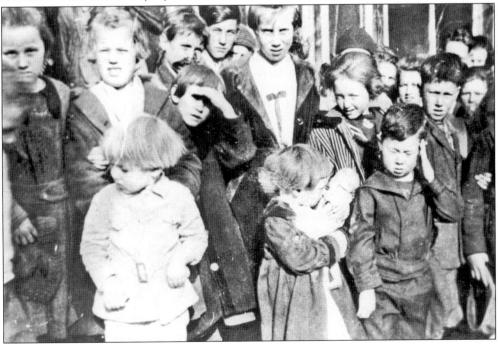

CHILDREN WERE SPECIAL. Children were a major part of Lydia Holman's mission. Here they are gathered at her house for one of her many special events. She provided maternity care to their mothers, safely delivered them, and then gave them books to read, helped clothe them, and, every year, gave each child in the community a gift for Christmas. As they grew, she also paid them to do odd jobs around her farm.

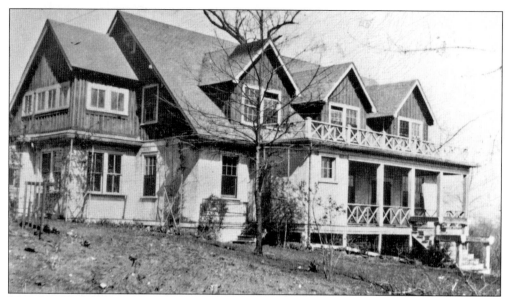

HOLMAN HOSPITAL. Area folks called this the "House of Health." Doctors at the facility reported to Nurse Holman. The railroad turned to Holman for the many injuries railroad employees suffered working on treacherous terrain. Holman convinced Holston Company officials of the advantages of having a local hospital to treat the injured workers and their families. The Holston Company gave 15 acres to the Holman Association to build and equip the 24-bed hospital, heralded by the local paper as "a boon to the people."

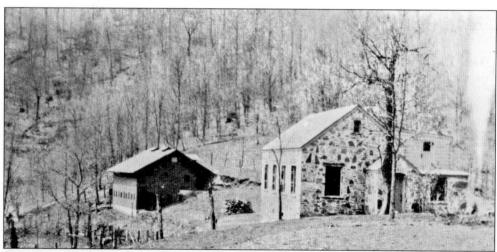

HOLMAN LIBRARY. Lydia Holman did much more than tend to health care. She loaned out books and would give another when the first was returned. No one was too young, too old, too rich, or too poor to receive books. The library building is today a glass art studio. Churches in the Boston area provided books, clothing, and some funds for the Holman projects. When Lydia built her first library, boys from another community set fire to it; the next building was made of stone.

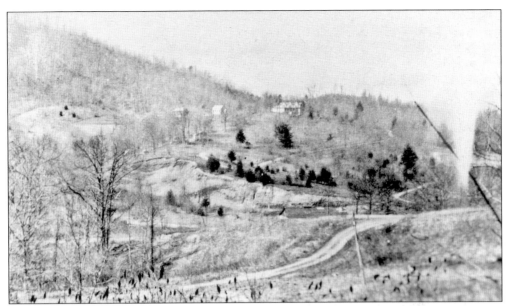

FROM ONE HILLTOP . . . In the early days, much of Altapass was timbered. This is a view of the Holman Hospital and Library from J.S. Bowen's lot on a neighboring hillside. Both areas are now heavily wooded.

. . . TO ANOTHER. This view is from Holman Hospital grounds looking back at J.S. Bowen's barn. The children playing in the yard could see much of the Altapass community. The train depot was across the tracks at the bottom of this hill.

SPECIAL DOLLS. Early in Altapass, children had very few toys. These little girls were proudly showing off their new dolls. From left to right are Sadie Rose McKinney, Bob Biddix, Nettie McKinney, and Terry, Gertie, and Theresa McKinney.

TENDING THE GOATS. Cecil Guy Hall helped care for Lydia Holman's goats. He and his father took the goats' milk to market.

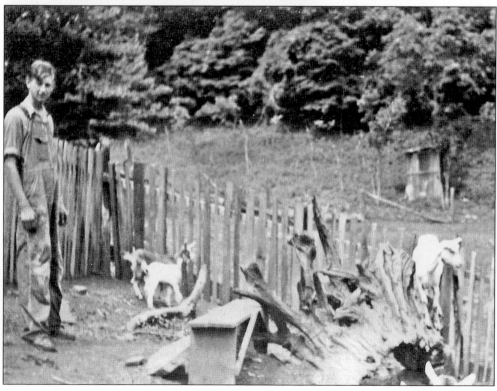

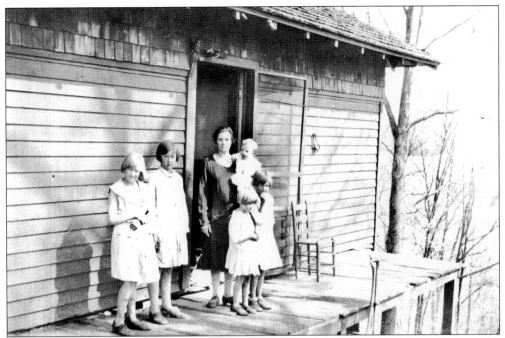

PICTURE FOR A BOOK. John and Carrie Snyder Hall lived in one of the houses out from the Altapass Inn. This photo was taken for Muriel Sheppard's book *Cabins in the Laurel*. Carrie was washing clothes outside when the photographer asked to take pictures of her and the children in their work clothes. She refused and only allowed their picture to be taken after she and the girls dressed in their Sunday best. From left to right are Velma, Mildred Mae, Carrie Snyder Hall holding Beatrice, Helen, and Ruth.

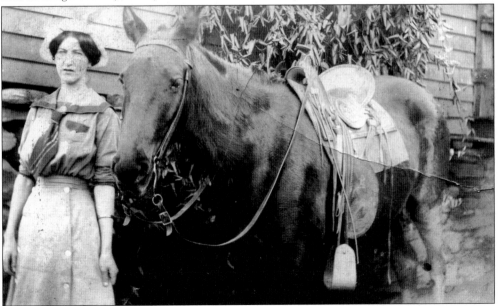

TRAVELING BY HORSEBACK. Bess Dale traveled around Altapass on a horse. For many years, the roads of Altapass were muddy and rocky. Lydia Holman took it upon herself to ask county officials for paved roads even though she preferred horseback for herself.

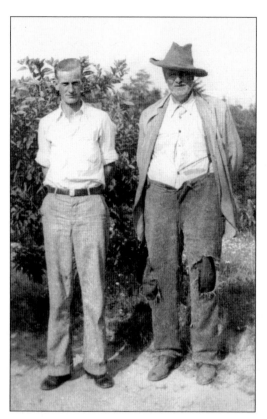

"Uncle" Will McBee. Brack McKinney (left), driver of the bus that brought guests to the Altapass Inn, visits here with "Uncle" Will McBee. The Great Flood of 1916 saw 22 inches of rain in a 24-hour period, which caused massive mudslides that carried away McBee's neighbor's cabin, sweeping the owner and his children away; they did not survive. Will carried his son, Fred, a polio victim, to higher ground. Will's cabin was one of few not in the way of the mudslide on Humpback Mountain.

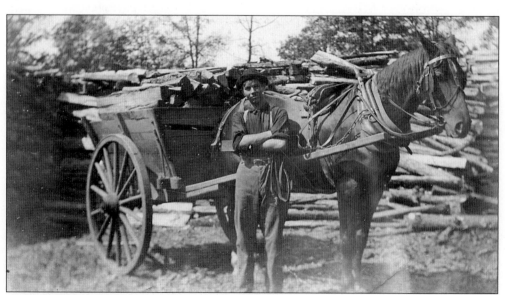

James McKinney. This young man from Altapass was deaf and attended the North Carolina School for the Deaf in Morganton.

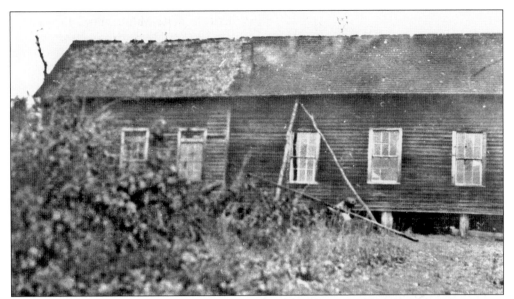

EARLY SCHOOL. This is the one of the first school buildings in Altapass. As a young man, Clarence Hopson taught at this two-room schoolhouse, which operated five months a year. He gave his memoirs to the library at East Tennessee State University in Johnson City. He reported that Altapass had two stores, one hotel, and the railroad station. The only recreation was pitching horseshoes. For entertainment, he walked to Spruce Pine, and to get back to Altapass after dark, he hopped a freight train when it slowed down for a sharp curve and rode back to Altapass, where he jumped off while the train disconnected its pusher engine.

STUDENTS. These children attended school in a building near the present-day fire department in Altapass.

PLAY TIME. Paul McKinney enjoys the view from an old wagon bed. Between chores, mountain children created their own fun with everyday items they found around the house and farm.

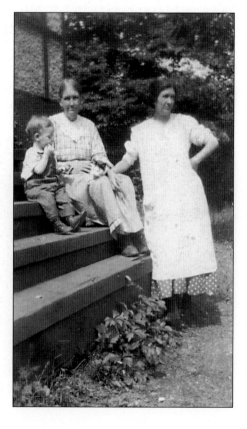

VISITING AT THE BOARDING HOUSE. "Aunt" Em Biddix and Annie Biddix relax on the steps of the Railroad Boarding House. The child is unidentified. Aunt Em and her husband, Will Biddix, managed the Boarding House in the 1930s. Later managers were Calhoun (a musician) and Edith McKinney, depot managers Carl and Mary Letterman, and John and Carrie Hall.

SCHOOL SITE. This home at the corner of Altapass Road and Davenport Road, near the fire station, is on the location of the old school building.

HUMPBACK MOUNTAIN IN ALTAPASS. Bonnie McKinney Riddle and her husband, Ed, had a large family. Their children raised their own families near their parents on Humpback Mountain. The Riddles and offspring comprise the majority of the residents on Humpback today. Visible from left to right are Rosanne Bryant McKinney, unidentified child, Grace Riddle, unidentified child, Garrett Bailey, Candy McBee (child in front), Bessie Riddle, Clyde Riddle, and Bonnie Riddle.

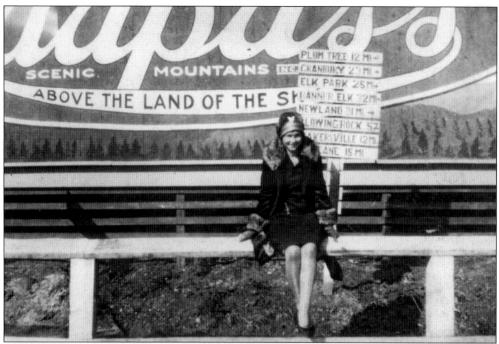

MODELING FOR ALTAPASS. At the height of the flapper era in 1925, Bertie Lee Wilkie Boyd poses fetchingly in front of a billboard advertising the attributes of Altapass, "Above the Land of the Sky." Asheville calls itself "The Land of the Sky."

OLIN'S STORY. Olin Hefner told this for *Stories Worth Telling*:

> I was about six or seven. . . . In about 1932, our cows went dry. To get milk, we had to walk to Aunt Marg's through the woods at a place called Booger Branch. . . . We went to Aunt Marg's and we stayed too long, 'cause she told us this story. She said, "There near Booger Branch, you will hear something drop and crash just when it is getting dark." Well, we had to walk back by Booger Branch around dark. I had the milk. I was thinking about Aunt Marg's story when, CRASH, WHAM! Well, I was the first person in space! I took off and they had to catch me. My sister had thrown a great big rock in the branch. The milk was still in the bucket because of centrifugal force.

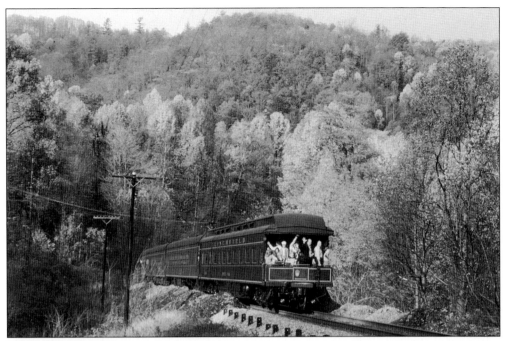

WHEN WINTER TURNS TO SPRING. A day spent enjoying spring blooms in the mountains on the Clinchfield is a reason to celebrate. What is finer than the view from the back of the train?

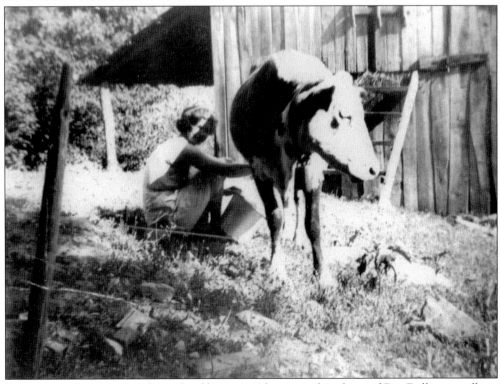

DOING THE CHORES. Another side of living in Altapass is this photo of Bea Dellinger milking old Bessie. In the country, folks kick up their heels, but only after the day's chores are done.

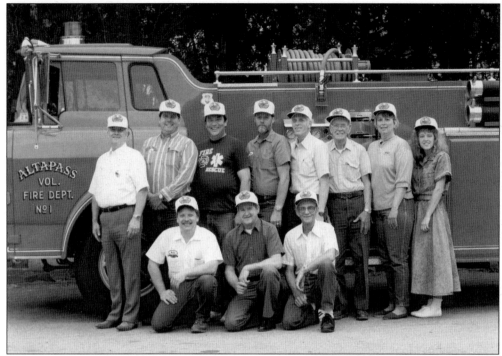

THE ALTAPASS FIRE DEPARTMENT. Volunteers of the Altapass Fire Department take on the awesome responsibility of protecting the community during fire and other emergencies. The department received its charter in September 1984 and took two years to raise money for a building. These *c.* 1989 fire fighters are, from left to right, (front row) Wally Cox, Norris McKinney, and Ray Saxon; (back row) Lloyd Glenn, John Slayton, Frank Byrd, Blaine Biddix, Paul Thomas, Lee Medford, Atlas Benton, and Donna Collis.

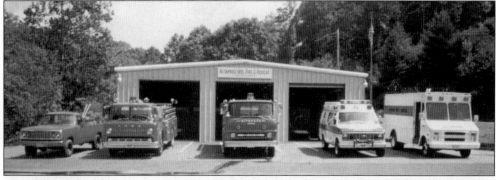

DONATED LAND. H. Lee Medford donated property for the first Altapass Fire Department building. The building, at the corner of Altapass Road and Henredon Road, has three bays and a meeting room. Initially two trucks were purchased, and the department was certified by the North Carolina Department of Insurance with a 9-S rating.

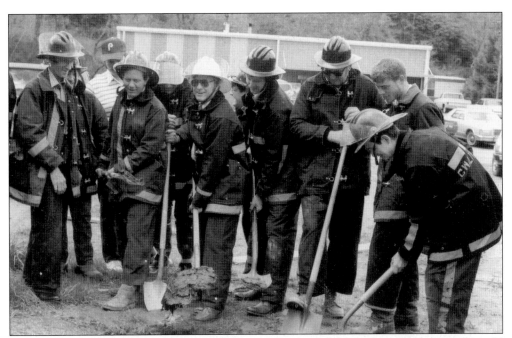

VOLUNTEER FIREMEN BREAK GROUND. The new fire station was built in 1986–1987. The old Lee Medford store building across the street was later purchased, and three additional bays, a meeting room, office, and kitchen were added with a second building. The second building is now named Medford Hall. In 2001, Altapass Fire Department and Grassy Creek Fire Department merged to become Parkway Fire and Rescue, Inc.

A DEED FOR FIRE FIGHTERS. H. Lee Medford presents the deed to Fire Chief Lloyd Glenn Jr. for the property he donated for the first Altapass Fire Department building, shown on page 86.

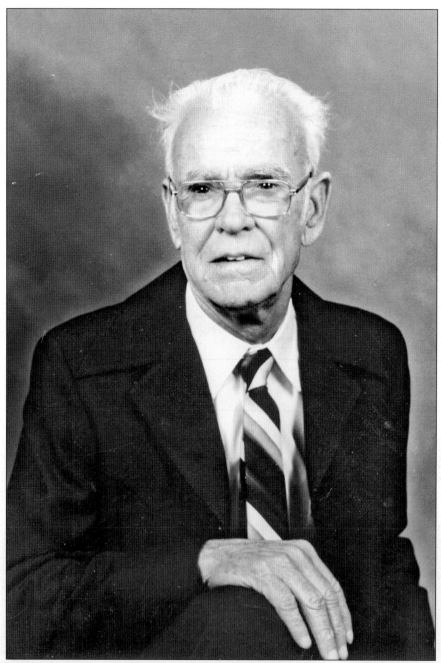

LEE MEDFORD (1911–1993). H. Lee Medford was a leader in the economic development of Altapass. As a young man during the Great Depression, he worked on track maintenance and telephone lines for the CC&O Railroad. Later, he worked on survey crews for the building of the Blue Ridge Parkway. In the 1930s, Medford built a general store. Later he established his own sawmill business and then went into timbering, shrubbery, apple growing, mining, and railroad salvage, each providing employment to local workers during economically difficult times. Medford was also instrumental in recruiting manufacturing businesses. He and Sam Phillips were largely responsible for the Henredon Furniture Plant building a factory in Altapass.

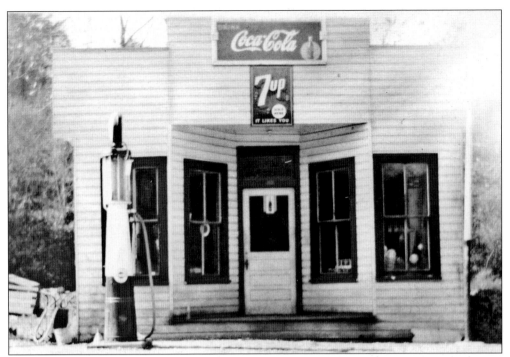

MEDFORD'S GENERAL STORE. The store was built in the early 1940s along Little Rose's Creek, at the present location of Medford Hall. This was one of the first ventures by Lee Medford to bring jobs and comforts to Altapass residents. This building was torn down to make room for a larger store.

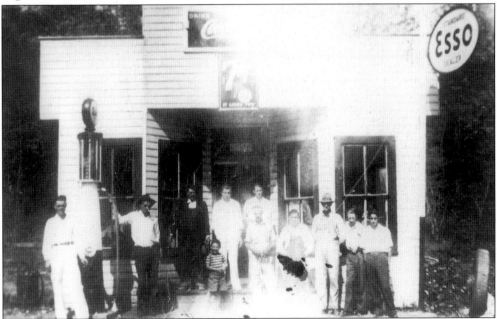

STORE VISITORS. From left to right are Lee Medford, George Pittman, Nelson Biddix, Hampton Sullins (the small child), Hugh McGuire, Will "Teed" Biddix, Ed Medford (in front of Teed), Jim Benfield, John Hall, James Graybeal, and Glenn Styles.

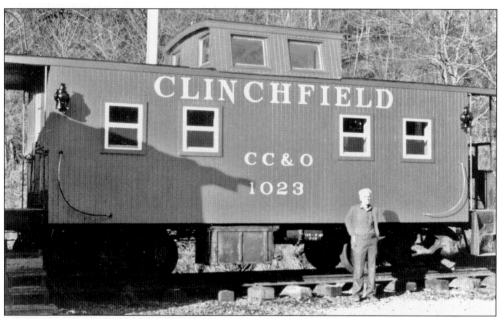

RAILROADS IN HIS BLOOD. As teenagers, Lee Medford and his friends would gather around the railroad water tank at the old Avery siding and "hobo" on the train, up the mountain about 30 railroad miles. At the top, the boys jumped off and walked along the Eastern Continental Divide, returning the two and a half miles down the mountain on foot.

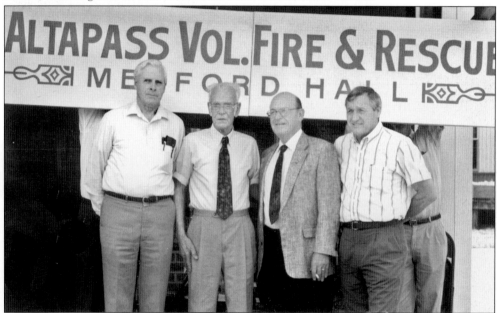

THE CABOOSE. Medford's own red Clinchfield caboose is now located close to the tracks across from the First Baptist Church on Altapass Road. The caboose was a museum with railroad memorabilia, from recordings of railroad songs to old photographs. In 1992, H. Lee Medford was honored for his outstanding service to North Carolina in a ceremony at the Altapass Fire Department. The fire hall was then named "Medford Hall." From left to right are Mitchell County commissioner Robert Runion, Lee Medford, unidentified, and Commissioner Wayne Hall.

LENNIE MEDFORD. Lennie Biddix married Lee Medford on May 27, 1931. Seven children were born to them, with five surviving. Lennie passed away in 2003 and is lovingly remembered by her family and friends. The Medfords lived in the home built by J.S. Bowen until Lennie's passing.

YOUNG LEE MEDFORD. Lee Medford was born March 18, 1911, in the North Cove section of McDowell County. He only spent a short time working for the railroad, but the sound and smell never got out of his blood. While a youth, he "hoboed" up and down the mountain on freight trains. Occasionally, he rode in the engine in return for a few tunes on his harmonica. He once took the helm of one of the heaviest Clinchfield engines. His biggest thrill was sounding the wailing train whistle.

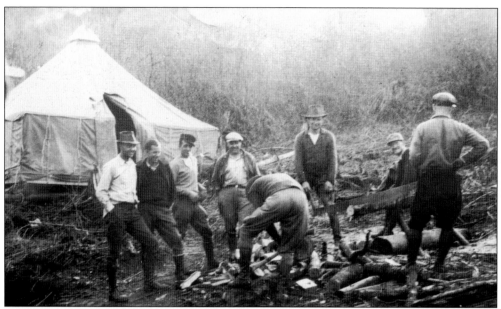

SURVEYORS. Lee Medford worked on the surveying crews in the 1940s for the construction of the Blue Ridge Parkway that passes through Altapass.

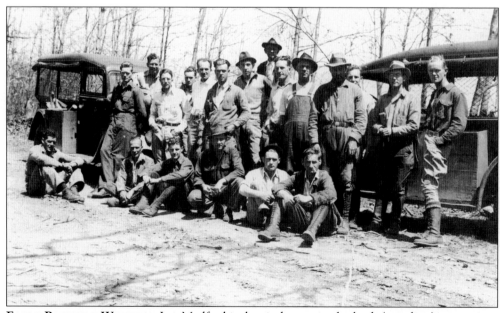

EARLY PARKWAY WORKERS. Lee Medford is the sixth man in the back (standing) row.

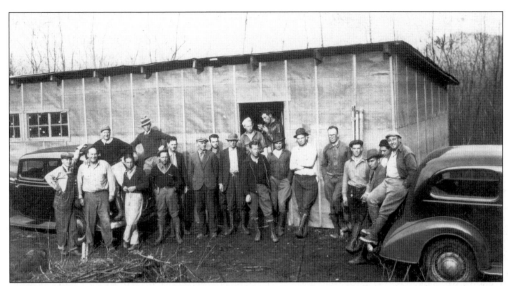

WORK IN HARD TIMES. Lee Medford is fourth from the right in this surveying crew. The actual construction of the Blue Ridge Parkway was a major Depression-era project served by Civilian Conservation Corps (CCC) and Emergency Relief Administration construction crews. Four CCC camps were established along the route, each averaging about 150 men.

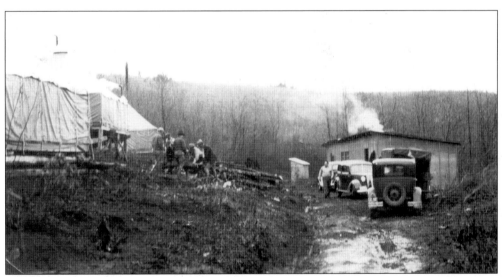

A DREAM THAT BEGAN AT ALTAPASS. The vision of a scenic mountaintop highway was planted in the minds of legislators beginning with the Crest of the Blue Ridge Highway project, which ran out of funding during World War I. Three decades later, the Blue Ridge Parkway became a reality. On the parkway, between mile 317.6 and 318.7, a traveler follows closely the original path of the Crest of the Blue Ridge Highway envisioned by Col. Joseph Hyde Patt, head of the North Carolina Geological and Economic Survey in 1912.

HOUSING. This is a camp that housed surveying crews working on the Blue Ridge Parkway in the 1930s.

CONSTRUCTION ACCIDENT. When the construction began for the parkway, Lee Medford worked as an inspector on the project. He told of seeing a newly excavated rock face burst under pressure, killing one of the contractors working on the job. The man's body was carried to Marion in a Model A Ford.

ALL THAT IS LEFT. These concrete pads once held pillars for the Altapass Inn on a hill above the Altapass Baptist Church. The inn printed elaborate brochures touting the offerings of the inn and the attractions nearby, including inviting descriptions of the Crest of the Blue Ridge Highway. The highway was to connect the Bristol to Washington Highway, on the north, with the Central and National Highways on the south. A crew of 100 men began construction in July 1912.

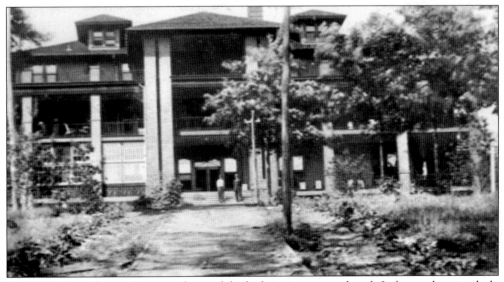

IN 1915. The Altapass Inn was the model of a luxurious resort hotel. It featured a nine-hole golf course just down the hill from the inn, complete with shuttle service.

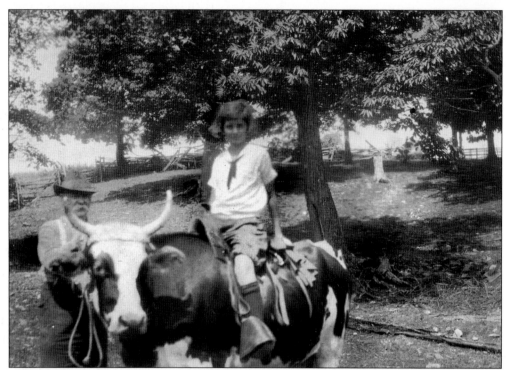

A Mountain Experience. "Uncle" Boots McKinney saddled his steer to give Harriet Hand a ride on his farm in Little Switzerland. Boots was the grandson of Charlie McKinney. Uncle Boots loved people and always had time to treat them to special experiences on the farm.

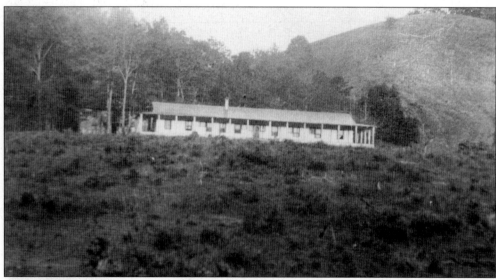

Conasoga Inn. Conasoga is a Native American name for this remote area meaning "beautiful valley of the rocks." This inn was on Arnold's Knob, which today is identified as the mountain behind the Henredon plant. It was close to the old Yellow Mountain Trail that brought settlers into the McKinney Gap region. This, and the Altapass Inn, accommodated early tourists.

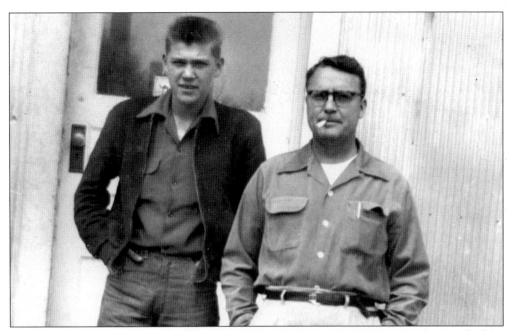

STORE AND RAILROAD SALVAGE. Franklin Hefner (left), Lee Medford's son-in-law, worked for Louis Biggerstaff (right), the proprietor of the second store Lee Medford built. The post office located in the store was the last post office in Altapass. Biggerstaff ran the store from the mid-1950s to the early 1970s. Lee Medford's daughter, Norma, and her husband, Paul Thomas, were the next proprietors. After the deaths of Paul and Norma, the Altapass Fire Department was built on the store's land.

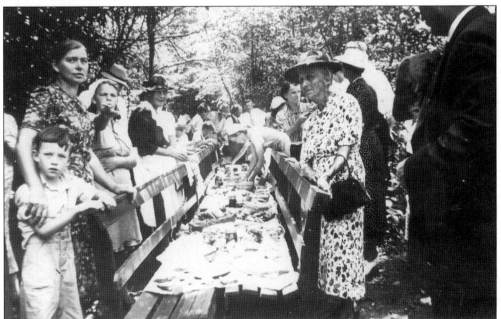

CHURCH OF GOD PICNIC. The Altapass Church of God congregation, seen in 1941, utilized wood benches to serve as tables for the church picnic. These occasions called for the finest offerings from members' kitchens.

JACKSONTOWN. Jacksontown is a neighborhood bordering the original path of the Crest of the Blue Ridge Highway. The area's oldest resident, Biddie Frances Jackson, was born February 9, 1850, and died October 18, 1955. She was the daughter of Maryland Austin Francis of McDowell County. Biddie was the mother of six children, with three living in Altapass: T.T. Jones, Mrs. Sarah Byrd, and Mrs. Mary Owens Ray. She had nine living grandchildren and around 100 great-grandchildren and great-great-grandchildren.

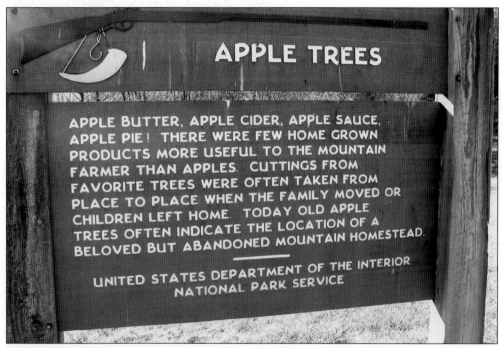

PARKWAY MARKER. This sign is displayed on the Blue Ridge Parkway close to the original locations of the Hefner Orchard, planted by the Clinchfield's Holston Land Company, and the privately owned Keywaden Orchard. South of Jacksontown Road is a Christmas tree farm that is partially on the land of the former Keywaden Orchard.

GREAT VIEW! Geneva Biddix enjoys the scenery from the new Blue Ridge Parkway overlooking the apple orchard in the mid-1950s. The parkway was a dirt road through Altapass until the late 1950s.

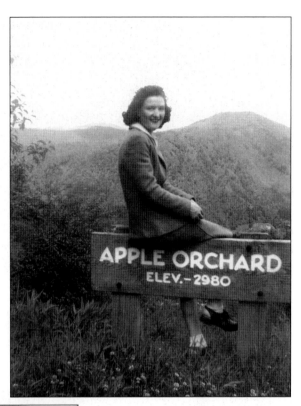

AT THE ORCHARD. From left to right, Jo Retta, Blake, and Dean Hefner, three of the children of Altapass orchard manager Deward Hefner, play in the orchard yard c. 1941. The packinghouse, the spray mixing building, and the barn are in the background.

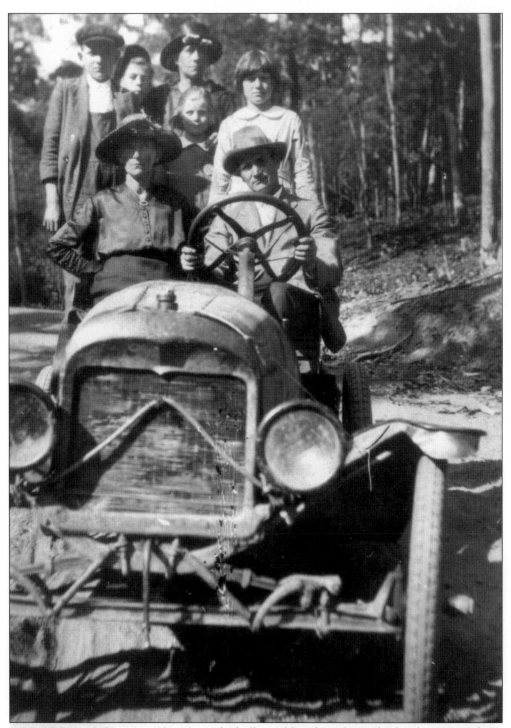

A New Mode of Travel. Altapass roads challenged Sunday rides in the family 1923 roadster. The Sullins and Elliot families take a spin on Penland Road. Joe Sullins and his wife, Cora, are in the front seat. In back are, from left to right, their son, Carter Sullins; Vick Elliot; Vick's mother, Lillie Elliot; and two of Lillie's daughters.

SAM AND MOLLIE MCKINNEY FAMILY. This picture was made around 1954. From left to right are (front row) Ora McKinney; (middle row) Myrtle Lois, Joe, Emmalou, Kathleen, and Guss, who was away in the service and was added later; (back row) three unidentified.

CONLEY MCKINNEY FAMILY. From left to right are Virgil McKinney, Gertrude Ellis, Faith Wiseman, Connie Hall, Willard McKinney, Lora Jane Hefner, Florence Snipes, and Fred McKinney.

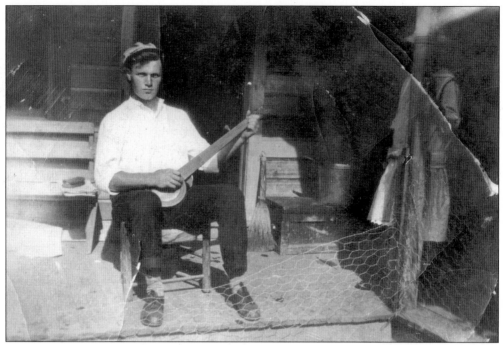

Front Porch Pickin'. James Tensley Wiseman, a descendant of early settler William Wiseman, is playing a homemade banjo that he probably made himself. He was the father of well-known musicians Fiddlin' Jim Wiseman, Kent Wiseman, and Lois Moore Constable and area music promoters Roy "Bud" Wiseman and Lila Lovelace.

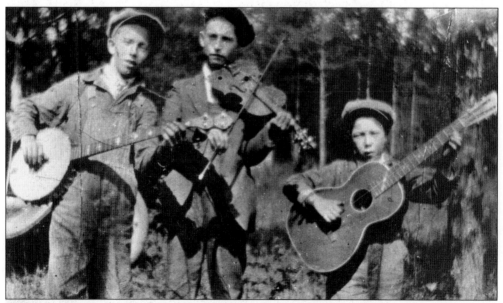

The Queen Brothers. Jack, Reid, and Coy Queen made up a well-liked Altapass band that played for birthday parties and family gatherings. They also played on a radio station from Cincinnati, Ohio, in the mid-1930s.

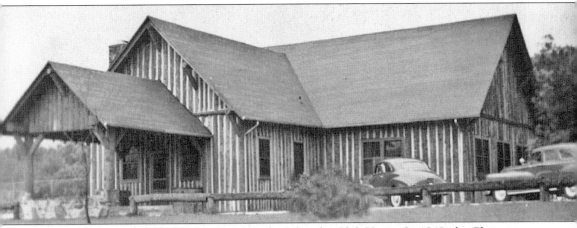

THE CLUB HOUSE. The Teen Timer Klub gathered at the Club House. In 1948, the Christmas Formal organizers were dance master Fred Biddix Jr.; co-chairmen Jean Wilson Jr., Tommy Vance, and Nancy Henline; decorators Ann Whitesell and Betty Burleson; invitation writer Glenda Radford; and Evelyn Loven, who organized refreshments. A lake behind the Club House, overlooked by a deck, was a flooded mine. The Club House was frequently used for musical programs and family reunions. Lulu Belle and Scotty Wiseman entertained there, as well as many local musicians.

TEEN TIMER DANCERS. Dancing among the elaborate decorations at the Club House are, from left to right, Dick Taylor, Anita Sparks, Ginger Freeman, Irma Garland, Suzanne Myers, and Bud Duncan.

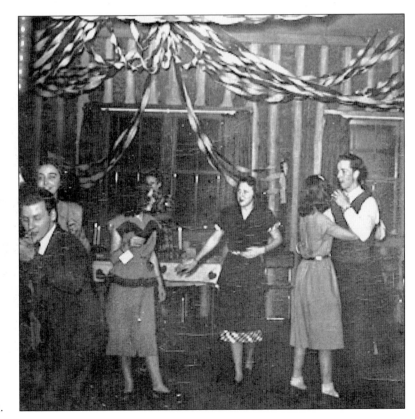

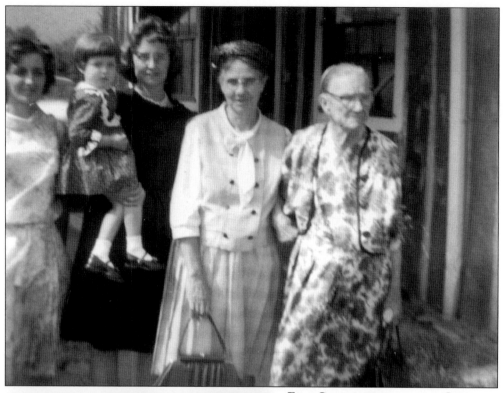

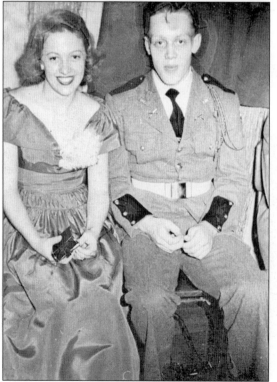

FIVE GENERATIONS AT THE CLUB HOUSE. Five generations of Rosanne McKinney's family posed on the porch of the Club House during a family reunion. From left to right are Paulette Lowery Dellinger, Rosanne's great-granddaughter; Debby Dellinger, great-great-granddaughter; Sis Lowery, granddaughter; Bonnie Riddle Forbes, daughter; and Rosanne Bryant McKinney.

TEEN TIMER KLUB. Nancy Henline and Ted Dent show off their formal attire at a Christmas dance. The Teen Timers had three black-tie dances every year at the Club House. The owners of the Club House provided the funds for decorations and refreshments. They also reserved the building free of charge for the group one Saturday and one Thursday of every month. Nancy Henline and Suzanne Myers (Cheek) sang together at the original Carolina Barn Dance at the historic Carolina Theater in Spruce Pine.

HARRIS HIGH SCHOOL, A HISTORY. Col. C.J. Harris of Dillsboro, North Carolina, came to Mitchell County to start the Harris Clay & Mineral Company, spurring rapid growth for the town and schools. When Spruce Pine was incorporated in 1907, a two-story frame structure served as a schoolhouse. Colonel Harris donated a tract of land from his holdings for a new, much larger building attended by Altapass and Spruce Pine students. The school was named after his brother, Dr. William Torrey Harris, a nationally recognized educator. A new building was built in the early 1950s. The school later moved to the present facility at Ledger. The building shown here housed Harris Elementary School until 1978.

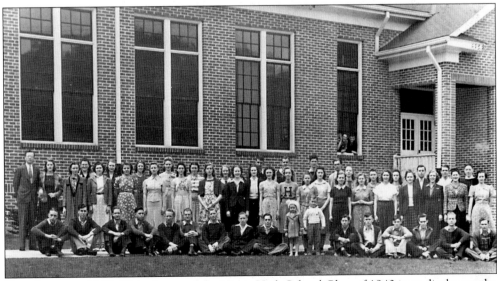

THE CLASS OF 1940. This picture of the Harris High School Class of 1940 is on display on the walls of the present Pinebridge Inn, built on the site of the original high school. A monument still stands there honoring Dr. Harris.

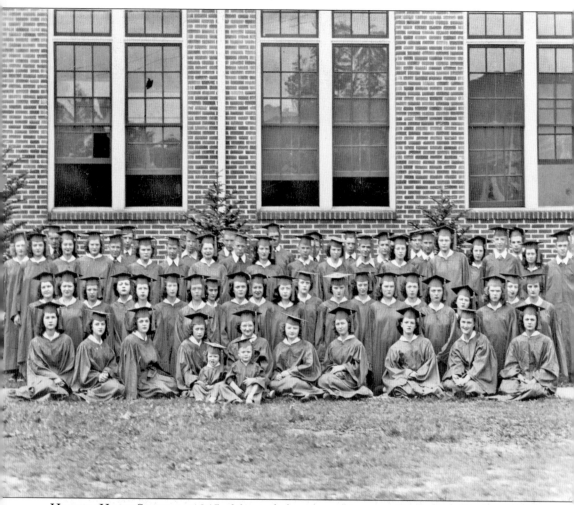

HARRIS HIGH SENIORS, 1945. Most of the class photos at Pinebridge do not include identifications. The Class of 1945 is an exception. The mascots in front are Priscilla Fortner and David Houston. The students are, from left to right (front row) Lucy Emma Stewart, Wanda Sullins, Perry Lee Dryman, Elizabeth Phillips, Janet Young, Marjorie Parlier, Christine Hall, Ruth Bell, Ruth Glenn, and Gladys Smith; (middle row) Eunice Robinson, Tilda Cox, Gertrude Pitman, Jo Howell, Hilda Cox, Mary Lee McGee, Daphne Gillespie, Evelyn Styles, Jean Bailey, Louella Crowder, Vivian Brinkley, Naomi Hollifield, Evelyn Dale, Irene Jones, Laura Lou Boone, Doris Rhyne, Lois Smith, Delia Beam, Inez Smith, Louise Henline, and Juanita Buchanan; (back row) Ruth McGee, Wilma Hoyle, Harold Biddix, Grace Glass, Ella Hollifield, Bobby Henline, Tom Whittington, Dixie Hogan, Steve Sparks Jr., Max McKinney, Hope Letterman, James Hollifield, William Hall, Elizabeth Anglin, Jack Braswell, Herbert Garland, Jim Hollifield, Elinore Woody, James Hall, John Woody, Hugh Conley, Colleen Wright, Bobby Vance, Beecher Young, Wilma Ollis, Evelyn Pendley, Jack Biggerstaff, Bobby Riddle, Juanita Greene, Virgil McKinney, and Phillip Snyder.

PROM NIGHT. This photo, displayed in the Pinebridge Inn hallway, shows Harris High girls, apparently ready for the senior prom. By this time, Altapass students were attending school there.

HARRIS ELEMENTARY SCHOOL THEATER. The present Pinebridge Inn dining room was originally a school theater used for drama and choral presentations. It also provided a stage for community use. This picture was taken in the auditorium around 1955, when the future graduating class of 1962 presented a historic play.

SQUARE DANCE CALLER. "Doc" Davenport called the square dances for the Teen Timer Klub dances. Doc was a dentist in the area, well loved by the young people. Doc's family was one of the first families that settled near McKinney Cove in the Blue Ridge Mountains.

LIVED ON ARNOLD'S KNOB. In their early years, this McKinney family lived on a farm on the south side of Arnold's Knob near the location of the old Conasoga Inn. They are, from left to right, (front row) Theresa McKinney Newton, Nettie Sarah McKinney, Gertie McKinney Johnson, and Sadie McKinney Andrews; (back row) Terry Hughes McKinney, David Jack McKinney, and Paul Marion McKinney.

Five

DOWN THE ROAD

ROADS. Roads have made Altapass, starting with the Yellow Mountain Trail, then the Clinchfield Railroad, the Blue Ridge Parkway, and the Overmountain Victory Trail. The newest road is actually the oldest road. The Overmountain Victory Trail was established 25 years ago in 1980. What lies down the road for Altapass?

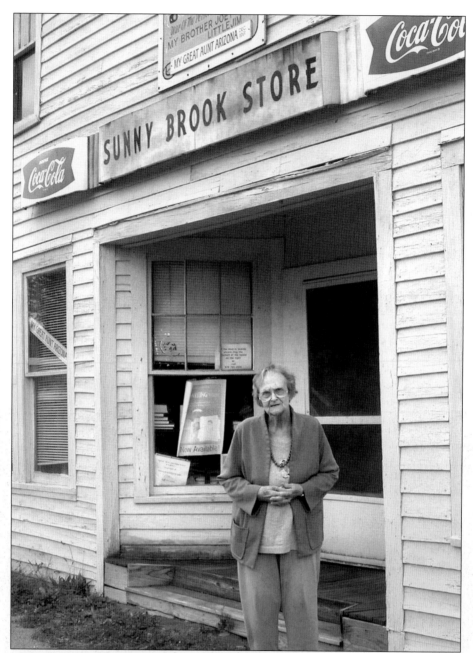

RUTHIE. Ruth Houston, affectionately called "Ruthie," stands in front of the building that was both her home and her general store. She and her husband, J. Myron Houston, raised their family here on land first owned by Samuel Bright and then by William Wiseman. Myron Houston was a historian who wrote about the land that reaches east to Altapass and McKinney Gap. The Houstons' daughter, Gloria, became a famous writer of historically accurate books for youth, describing life in the mountains as it really was. Ruthie and Gloria are campaigners for keeping the heritage alive and well. They believe that preserving the local heritage is a valuable part of the community. The Sunny Brook Store is now a museum and shop honoring the literary work of Gloria and the historic preservation work of the family.

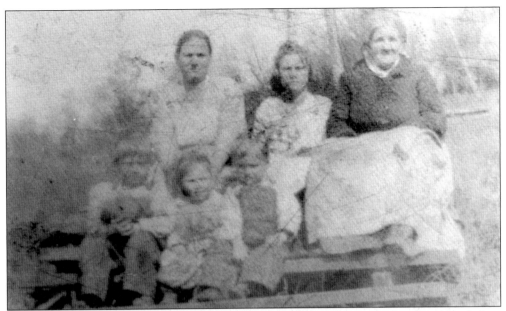

HONORING OUR HERITAGE. In murky old photographs, families see the strength of their heritage. Appalachian families still live on the land that ancestors acquired as grants. With their children, they've cleared land, hoed gardens, laid railroad tracks, and opened stores. They know that hard times and strong families go together. Pictured are, from left to right, (front row) children Ross Riddle, Lollie Riddle (Lowery), and Bill Riddle; (back row) Lula Biddix Riddle, Dorothy Riddle Styles, and Sarah Galetha McKinney.

REMEMBERING OUR HISTORY. Altapass is a place where people can recite their genealogies back to Charlie McKinney, William Wiseman, or Martin Davenport. The ups and downs of the local economy have been faced by the community with strong religious faith and belief in itself. When the train was discontinued in the mid-1950s and the Altapass depot was torn down, the town remained, along with factories, small businesses, churches, and schools. Now factories are giving way to international competition, and once again Altapass looks to the strengths nurtured by its past.

BLUE RIDGE VISTA. The Blue Ridge Parkway approaches the beautiful Bear Den Overlook, which offers a sweeping view of the mountains rising from the base of North Cove up to Altapass and on to the Black Mountains on the western skyline.

THE BLUE RIDGE PARKWAY. In the 1940s, the Blue Ridge Parkway was opened through McKinney Gap. This road brings visitors from all over the world to the doorstep of Altapass. Approximately 17 million people per year travel the parkway. Travelers enjoy stunning scenery and close-up looks at the natural and cultural history of the mountains. The Parkway Visitors Center and the North Carolina Museum of Minerals, above, are three miles from Altapass.

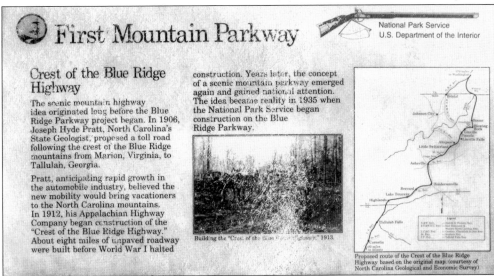

First Mountain Parkway

National Park Service
U.S. Department of the Interior

Crest of the Blue Ridge Highway

The scenic mountain highway idea originated long before the Blue Ridge Parkway project began. In 1906, Joseph Hyde Pratt, North Carolina's State Geologist, proposed a toll road following the crest of the Blue Ridge mountains from Marion, Virginia, to Tallulah, Georgia.

Pratt, anticipating rapid growth in the automobile industry, believed the new mobility would bring vacationers to the North Carolina mountains. In 1912, his Appalachian Highway Company began construction of the "Crest of the Blue Ridge Highway." About eight miles of unpaved roadway were built before World War I halted

construction. Years later, the concept of a scenic mountain parkway emerged again and gained national attention. The idea became reality in 1935 when the National Park Service began construction on the Blue Ridge Parkway.

Building the "Crest of the Blue Ridge Highway," 1913.

Proposed route of the Crest of the Blue Ridge Highway based on the original map. (courtesy of North Carolina Geological and Economic Survey)

THE PARKWAY AT ALTAPASS. The 469-mile-long Blue Ridge Parkway, a national park and motor road combined into one, came to Altapass in the 1940s—the third transportation revolution in its history. The Yellow Mountain Trail started settlement here 225 years ago, and 100 years ago, the railroad brought industry and prosperity. The parkway brings millions of tourists who wonder at the natural beauty and enjoy the North Carolina Museum of Minerals. Displays at parkway overlooks tell visitors about some of the historical highlights.

THE HEADWATERS OF MOUNTAIN MUSIC. This corner of Western North Carolina is rich in traditional mountain music. Places like the Carolina Theater (above) headlined the Carolina Barn Dance (below), featuring the cream of the "down home" music crop with names like Chet Atkins, the Carter Family, Kitty Wells, the Stanley Brothers, and Lulu Belle and Scotty Wiseman, as well as an outstanding collection of local performers. The theater is being renovated to revive its place as a major performance venue. The music tradition is alive and well, dating back to the times families sang while working long hours in their fields. "Pickin' " is highlighted at family gatherings, church picnics, and local businesses. In this area, music still has a personal touch.

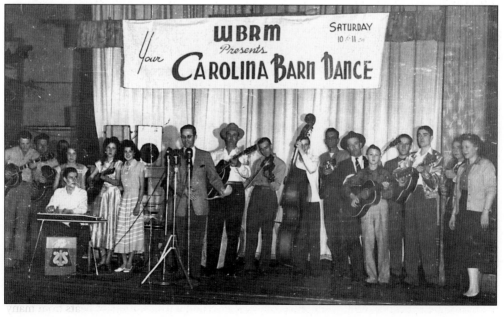

TOE RIVER VALLEY BOYS. The bluegrass sounds of Gus Washburn's Toe River Valley Boys, *c.* 1950–1970, kept mountain square dancers and cloggers counting the days until Saturday night, when these music makers lit the fire under their feet. In 2002, Red Wilson, on the far right, was honored with the North Carolina Folk Heritage Award.

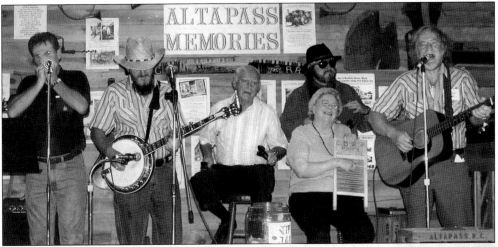

JOIN IN! Terry McKinney (far right, playing guitar) invites folks who play spoons, washboards, and jugs to join in with his band to keep alive the fun of mountain music traditions. Today's music is a merry mix of old-time country and bluegrass and a wide variety of beats from many cultures. The dance floor fills with mountain cloggers, waltzers, seniors swaying to the beat with their great-grandchildren, and tourists who hear the music and stop in to see what is going on. Yes, a happy time is had by all!

THE ORCHARD AT ALTAPASS. The railroad planted the historic orchard at McKinney Gap in 1908. In the early days of the railroad, the depot and the company store were gathering places for Altapass residents. Altapass was the main passenger station in the area. With the closure of this station, visiting moved to Lee Medford's grocery store. After the store closed in the late 1970s, there was no place for informal gatherings until 1995, when Kit Trubey and Bill and Judy Carson reopened the orchard. With live mountain music, clogging and two-step dancing, Appalachian memorabilia, storytelling, and porches for long visits with friends, the orchard became a community gathering spot. Each season, 50 or more local music groups take the stage to treat visitors from near and far to enjoy music of many styles and to take part in the camaraderie of a friendly, comfortable place.

STORYTELLING HAYRIDES. Bill Carson shows hay-riders a train passing on the Clinchfield Loops at the lower end of the orchard. His stories are historically credible and always entertaining. When the Carson family first purchased the orchard land, Prof. Harley Jolley, author of a major book about the building of the Blue Ridge Parkway, told them, "You've just purchased one of the most historic places along the entire length of the parkway."

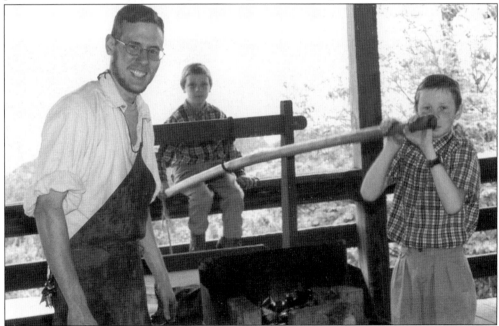

TALENTS GALORE. Every weekend from late May through October, displays and demonstrations entertain guests and give artists, craftsmen, authors, naturalists, and storytellers a chance to "show their stuff."

TAKING ON A PROJECT. Kit Trubey, left, purchased the Orchard at Altapass land late in the fall of 1994. Her goal was—and is—to keep the beautiful landmark safe from uncontrolled development. Her brother, Bill Carson, center, and her sister-in-law, Judy Carson, right, agreed to manage the project. Friends ask, "Isn't that a lot of hard work for your retirement years?" They answer, "Yes, but not a day goes by that we don't think, I wouldn't have missed this experience for anything!"

OPENING DAY. Memorial Day 1995 was so foggy the apple house was not visible from the parkway. Minutes before the first community covered-dish dinner and barbecue was to begin, the fog lifted, and Bill and Judy, looking a bit bedraggled, looked down the road, wondering what was ahead. What was ahead was a huge welcome from Altapass. Nobody came with brownies, but they brought mountain music, family stories, and wonderful old photographs that today are yet the core of the preservation projects at the Orchard at Altapass.

118

HOWDYYYY! The "Pearl Sisters," Regina Pendley, Ruth McKinney, and Judy Carson, do their part to keep alive Minnie Pearl's country humor. When the real Minnie Pearl was a young woman, she directed traveling play troupes that regularly came to the area and entertained at the Carolina Theater in Spruce Pine. The Bob Stroup family befriended Sarah Ophelia Colley (Minnie's given name) and entertained her troupe in their home. In the attic of the Stroup home are many affectionate thank-you notes from Minnie, signed "Love, Sarah O."

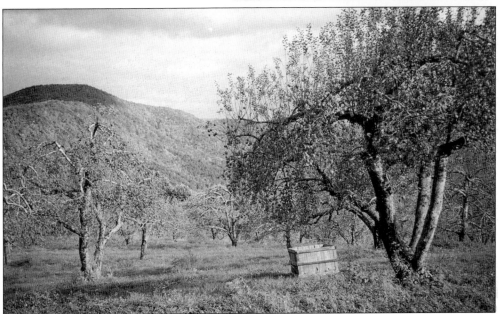

MOUNTAIN APPLES. Old-time mountain apples fill the branches of craggy old apple trees at the orchard. The apples are picked by hand from wide-based ladders that come to a point at the top to rest firmly in the branches. Visitors are treated to Virginia beauties, king luscious, Grimes golden, York, Stayman Winesap, McIntosh, transparents, and old variety golden and red delicious apples. Old mountain apples are famous for their flavor, not for their appearance.

BEAR DEN FAMILY CAMP GROUND. Several Altapass businesses provide entertainment and accommodations for visitors to the area. One is Bear Den Family Camp Ground, a popular facility offering tent and RV camping as well as cabins and RVs for rent. Bear Den is a private campground, with its entrance directly on the Blue Ridge Parkway. Family activities include lake swimming with a sand beach, lake fishing, play areas, a recreational building with ping-pong, square dancing, and more, and miles of nature trails.

A HARD YEAR. The Blue Ridge Parkway suffered three hurricanes in the fall of 2004, causing two large chunks of the parkway to fall down the mountainside. One of these was just a few miles north of Bear Den, and the other was 20 miles south of McKinney Gap, where a large slice of the parkway tumbled 400 feet down a cliff. Officials expect to have the problems repaired by the 2005 tourist season. Local chambers of commerce provide maps with detours well marked.

SPRINGMAID MOUNTAIN. This facility for families and groups stands directly on the old Yellow Mountain Trail that brought the first settlers to Altapass. Springmaid rents housing from cabins with one bedroom to accommodations large enough for family reunions and business gatherings. Springmaid Mountain features fishing, hiking, hayrides, sightseeing, and horseback riding.

VFW. Pitman-Norman-Glass VFW Post 8060 is located in Altapass. The Veterans of Foreign Wars helps veterans with medical and health needs, conducts military rites at funeral services for vets, and provides a place for vets and their families to gather socially.

CLOSE ENCOUNTER. A child lets a newly hatched monarch butterfly rest on his hand until it is ready to make its migratory trip to the mountains of Central Mexico, where it will spend its winter. Naturalist and writer Elizabeth Hunter teaches the basics of rearing monarch butterflies at an Altapass seminar.

GETTING YOUR HANDS DIRTY! Jann Welch shows budding potters how to create vases in clay. Naturalists, environmentalists, gardeners, geologists, botanists, authors, photographers, craftspeople, artists, and teachers are all part of the nearby community.

FLURIE'S DUTY. When Flurie Hollifield spent long hours hand-spinning thread for cloth that became clothing for the family, the process was a daily chore. Flurie was born in 1824. By the time she died in 1920—a hearty lady!—machines made the cloth for daily uses.

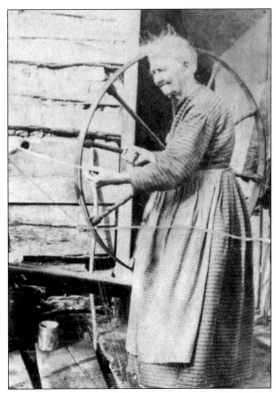

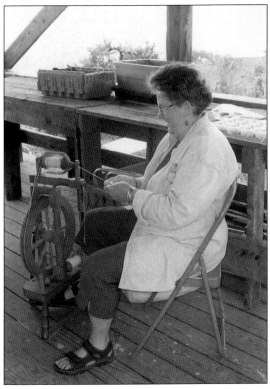

REVIVING TRADITIONS THROUGH ART. Edwina Bringle is an instructor at Penland School of the Arts. She teaches her classes the techniques of spinning thread for cloth. Art students experiment with materials and textures for creative projects. Edwina's little spinning wheel is far more portable than Flurie's. There are several photos of Flurie spinning, and she is always on her front porch.

ALTAPASS BAPTIST CHURCH. Built in the early 1940s, the Altapass Baptist Church supports a sizable private school. At the beginning, the church was located on Humpback Mountain Road. In the past few years, the church added the building on the right in this photo, and it is now constructing a new youth center and community building on the hill behind the church.

THE CHURCH OF GOD. Lum McKinney and Stacey Biddix were among the early organizers of the Altapass Church of God, established in 1940. In 1943, a one-room building was constructed called the "Little Brown Church Building." A campground was purchased up the hill near the church in 1945, and the first camp meeting took place in 1946. In 1965, Arnold "Bud" Biddix spearheaded the construction of the right side of the building shown here. The present sanctuary, on the left, was added in 1999. Eugene Vannoy was pastor at the Altapass Church of God for 23 years.

THE BLUE RIDGE BAPTIST CHURCH. This church, in the Humpback Mountain community, was founded by Bonnie McKinney Snider Riddle Forbes and members of the Riddle, McBee, and Wiseman families. Bonnie Forbes was born in 1902 and lived to be nearly 100. From the time of the earliest settlers, Christianity was important to Altapass families. The churches have remained the central core of life in Altapass. Both the Baptist churches and the Church of God sponsor annual special meetings of faith. For the Baptists, these are revivals. For the Church of God, they are camp meetings. Both feature guest preachers, youth activities, gospel singing, and fine mountain meals. When the preaching is strong and the music stirring, some of these meetings last one, two, or even three weeks.

THE TEMPE MOUNTAIN FREEWILL BAPTIST CHURCH. This church began services c. 1955, with Harold O'Dear as pastor until his death in 2001. The early meetings were in a log cabin near Larkin Freeman's house. Freeman donated land for the present building on Tempe Mountain Road. Early elders were Lenny Hughes, Edgar Ledford, and Charlie Rose. The present pastor is Ralph Headrick.

BUSINESS IS ALIVE AND WELL. A Super Wal-Mart brought hundreds of jobs into to the area, helping to offset job losses in other industries. The store attracts residents from all over the region to buy goods here instead of taking those dollars away to the cities. Shoppers are likely to spend extra time at Wal-Mart visiting with friends.

TAKING CARE OF TRASH. The county's first household waste recycling center is located on Altapass Road. Bales of plastic and aluminum are proof that the people around Altapass support reuse of waste materials. The friendly employees run an efficient and clean operation, making a pleasant experience out of what could be a disagreeable chore.

MINING INDUSTRY. The Feldspar plant on Altapass Road has been in Altapass since the 1930s. It is a backbone industry for the local mines, processing ore into products for market.

MINING ROCKS. Davenport Road leads to a rock-mining business that digs rocks for construction and decorative uses.

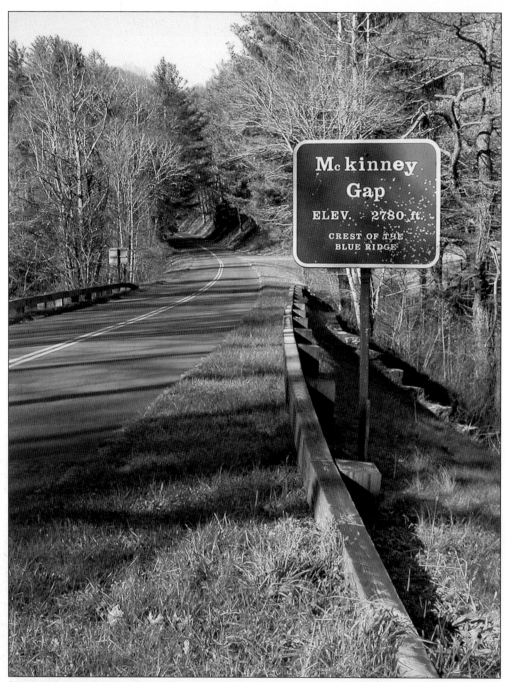

JUST ANOTHER MOUNTAIN GAP, AND A LOW ONE AT THAT. Who would think that this gap would witness the slow rise and sharp decline of a community, a railroad, and a way of life? When the Blue Ridge was a barrier, the low gap was crucial. Now a few feet higher or a few hundred miles no longer matter, and other places have supplanted Altapass. But the roots are deep here, and its people will not be forgotten.